THE
MOSAIC
ARTIST'S
HANDBOOK

Edited by Viv Foster

BARRON'S

A QUANTUM BOOK

First edition for North America published in 2006
by Barron's Educational Series, Inc.

All inquiries should be addressed to:
Barron's Educational Series, Inc.
250 Wireless Boulevard
Hauppauge, NY 11788
www.barronseduc.com

Library of Congress Control Number 2005925463

ISBN-13: 978-0-7641-5912-1
ISBN-10: 0-7641-5912-7

QUMMAH2

Conceived, designed, and produced by
Quantum Publishing Ltd.
The Old Brewery
6 Blundell Street
London N7 9BH UK

Manufactured in Singapore by Universal Graphics Pte Ltd.

Printed in China by CT Printing Ltd.
9 8 7 6 5 4 3 2 1

THE
MOSAIC
ARTIST'S
HANDBOOK

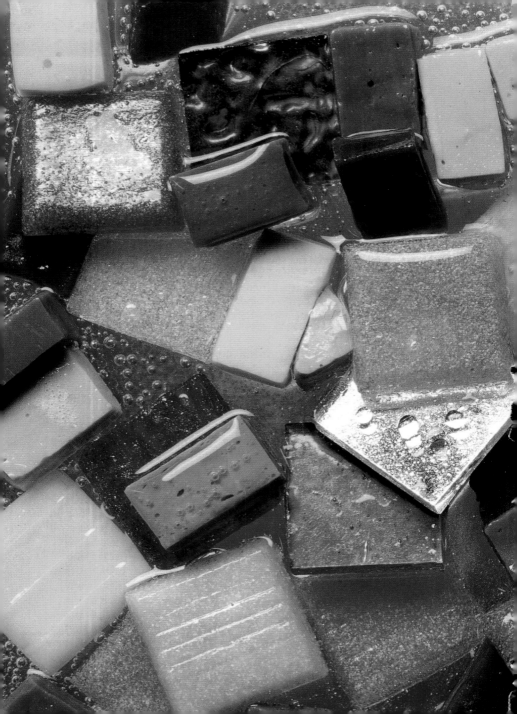

Contents

Introduction

All the essential techniques you need to make striking and unique mosaics are in this book, from cutting and laying tiles to creating your own intricate designs.

Mosaic is a decorative art form using "tesserae"—small pieces of glass, marble, ceramic, or stone—to create images or patterns. It is an extremely adaptable medium, and endless variations of subject, material, color, and application have been explored over the ages. The method of making mosaics has not changed much over the centuries and, even though it is an ancient art form, it has stood the test of time and is increasingly popular today as a versatile contemporary craft.

Mosaic has a legion of names: broken tile mosaic, pique assiette, bits and pieces, memorabilia, funky mosaic, fragment work, fantasy mosaic. An accepted appellation is elusive. Yet working artists seem unfazed by the lack of categorization and, therefore, acknowledgment that their art form has received. In the true artistic spirit, they are preoccupied by the creative process and not by public acceptance.

In the following pages, you will learn the secrets of how to create small and large mosaics. Broken dishes, tiles, glass, and memorabilia can be used to create fabulous gift and decor items as well as permanent works of art for your home or garden. Easy-to-follow step-by-step instructions with beautiful illustrations offer a wide variety of projects for varying skill levels. Some projects even can be adapted for children to do along with adult supervision.

Short History of Mosaics

Mosaic has evolved from the traditional mosaic of the ancient, Byzantine, and Renaissance periods into the unrestrained, more spontaneous mosaic of modern times. From the late 1800s through the mid-1900s, important strides in the art of mosaic were made by tenacious laypeople and professionals around the world, each with different motivations and results.

The history of mosaics is somewhat fragmented, as they flourished during certain periods, then vanished for centuries, reappearing later on and finding favor in seemingly unconnected civilizations. The earliest mosaics were fairly basic patterns made up of pebbles, as have been discovered in Asia Minor and the gardens of ancient China. Over time smaller pebbles replaced larger ones as the patterns and images became more refined. Pebbles were set closer together to achieve better detail; some were painted to increase the range of colors, and later outlines were accentuated with lead.

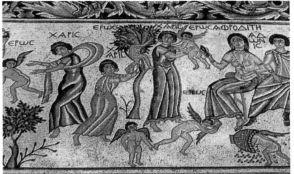

Left:: *The Hippolytus Hall, Madaba, Jordan, sixth century* A.D.

Below: *St. John, Leeds Parish Church, England, 1876.*

Tesserae were first introduced around the fourth century B.C. These were chunks of natural stone cut into cubes, which allowed pieces to be set much closer together and so gave even greater definition to images. Early mosaics were a combination of practical decoration and artistic expression. The ancient Greeks began by using pebbles to create flooring. Aztecs used mosaics to cover ceremonial objects with precious stones.

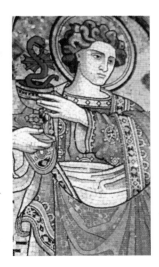

As subsequent empires spread through conquest, trade, or religion, demand for mosaics increased. Techniques improved as artisans traveled and passed on their skills, until eventually mosaics spread over the continents and throughout the world.

At the beginning of the twentieth century mosaics became popular once again, due to increased interest in the decorative arts. Art Nouveau used mosaics for highly decorative purposes, and this renewed interest was embraced by artists and architects alike. One of this century's most famous architects, Antoni Gaudi, took mosaics to new heights, literally-by covering buildings, park benches, and even rooftops in Barcelona with a multitude of multicolored ceramic tile mosaics, leading the way for other mosaic makers to follow.

The 1950s saw a rather uninspired resurgence of architectural mosaics in all kinds of utilitarian environments. Mosaics somehow survived the vogue for covering every available wallspace with dull, lifeless swimming pool tiles unscathed, and today they are enjoying another surge of popularity, becoming an increaseingly familiar sight in architectural features and public art works.

There is a vast wealth of both ancient and modern mosaics for you to gain inspiration from. Looking around today you will find that mosaics can be a lot more interesting than the mid-century postwar architectural cladding, 1970s shopping areas or gloomy pedestrian subways that are still in existence.

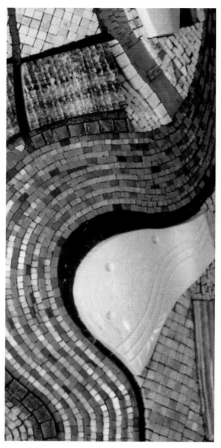

Right: *The River – detail from a Public Mural, by Haruya Kudo, Japan, 1997.*

Below: *Pigeon Mural – detail from St. Thomas Railway Arches, by Elaine M. Goodwin and Group 5, Exeter, England, 1991.*

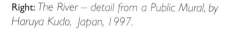

10

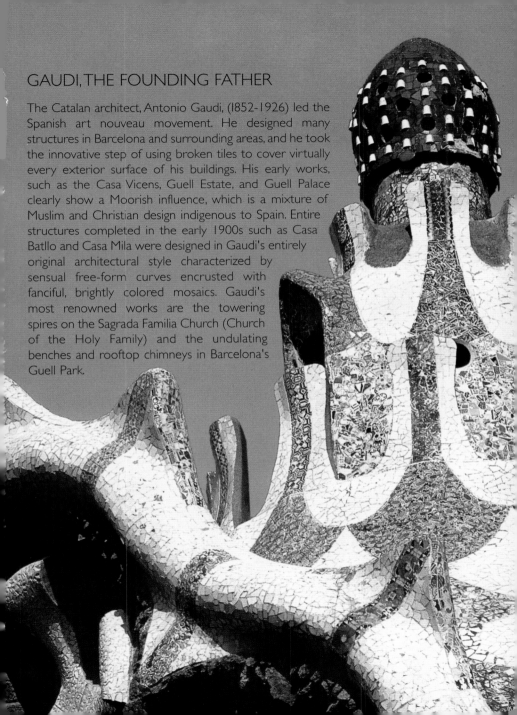

GAUDI, THE FOUNDING FATHER

The Catalan architect, Antonio Gaudi, (1852-1926) led the Spanish art nouveau movement. He designed many structures in Barcelona and surrounding areas, and he took the innovative step of using broken tiles to cover virtually every exterior surface of his buildings. His early works, such as the Casa Vicens, Guell Estate, and Guell Palace clearly show a Moorish influence, which is a mixture of Muslim and Christian design indigenous to Spain. Entire structures completed in the early 1900s such as Casa Batllo and Casa Mila were designed in Gaudi's entirely original architectural style characterized by sensual free-form curves encrusted with fanciful, brightly colored mosaics. Gaudi's most renowned works are the towering spires on the Sagrada Familia Church (Church of the Holy Family) and the undulating benches and rooftop chimneys in Barcelona's Guell Park.

Tools and the Workplace

The workplace can be as basic as your laundry room, basement, garage, or garden. The ideal situation is to be able to leave your tools and materials mid-project without cleaning up so you can return and immediately begin working again. Whatever your situation, a well-organized work area with good lighting and ventilation can make the process of mosaic making more enjoyable than you could have imagined. Unlike many other crafts, mosaic work can be as straightforward as you like. Many mosaicists use the minimum number of tools, relying on mosaic nippers for shaping the tesserae and gloved hands for grouting. If you prefer, you can invest in all the tools available to help you in your mosaic craft.

Surfaces

It is important to select the right surface for the right application. and this guide should help you to do so. The key issues are whether the surface will be exposed to water and how much weight can be supported.

GLASS

It is possible to fix to glass if you use the correct adhesives. This can give new applications for mosaic, as window lights for example. Glass can also be useful when you require a surface that is thin but stable.

MESH

Useful for working directly, you can lay the mosaic onto mesh and then fix it in place later.

MASTERBOARD

A stable material in wet conditions, masterboard can even be immersed in water and remain sound. If you want to use it under water, you should fix it in position, or it will float to the top.

TILE BACKER BOARD

A fairly new product on the market, this is an ideal surface for mosaic. It is light, and can be used in wet areas, both internal and external. It is made for use with cement-based adhesives. It is not suitable for floors.

PARTICLE BOARD

This is a very stable and inexpensive fixing surface. It is a good surface for small panels and interior tabletops. However, it is heavy and difficult to fit in screws and fixings. Do not use it outside or in wet areas, because if it comes into contact with water, it will swell up, throwing off the tiles. Always wear a mask when you cut it because the dust is said to be carcinogenic.

PLYWOOD

This is another good surface for interior mosaic. Marine ply can be used outside, but even this can layer if water penetrates if non-water-resistant fixings have been used.

SAND AND CEMENT

This is really the most adaptable surface there is, cheap, easy to make up, and flexible. You can make it fit the requirements of your site, feathering it (gradually laying it thinner) up to an edge, or making it really thick to cover all sorts of peculiarities beneath. A screed (a sand and cement bed laid on a floor) should not be less than about $3/5$ inch (1.5 cm) thick, and a rendered wall (a wall covered in sand and cement) should generally have an expanded metal lath (EML) fixed beneath it to protect the mosaic from any movement that may occur.

OTHER SURFACES

Using the right adhesives and primers, it is possible to fix mosaic to metal, terrazzo, fiberglass, and a whole variety of nonstandard surfaces. Check the manufacturer's recommendations.

Glues and Adhesives

Selecting the right adhesive is the key to making a mosaic long-lasting. Check the manufacturer's recommendations to ensure that the one you wish to use is appropriate for the location in which you plan to use it.

CEMENT-BASED ADHESIVE

There are a wide variety of cement-based adhesives on the market. Think about the characteristics you need your adhesive to have and choose accordingly. There are quick-setting adhesives, which might be useful if you are fixing to plaster or another material that should not have prolonged exposure to moisture. Some adhesives are better at sticking to wood than others. Some adhesives also have different sensitivities to temperature.

SAND AND CEMENT

Sand and cement is a highly adaptable adhesive. This is also probably the least expensive of all adhesives.

Lime is sometimes added to slow down the curing time, but this can be dangerous for the amateur to use.

BUILDING SILICONE

This is an excellent adhesive, although it has an unpleasant odor. Building silicone is useful for fixing mirror glass, because it does not interfere with the silvering.

WHITE CRAFT GLUE

There are two kinds of white craft glue, both invaluable for mosaic making. Water-soluble white craft glue is used as a holding medium when you are working in reverse. You should mix it half and half with water. If you use it unmixed, the work will still come off the paper, but it leaves plastic-type deposits on the face of the mosaic, which are time consuming to remove. It is also sometimes known as washable white craft glue.

Non-water-soluble white craft glue is used for panels and decorative pieces indoors. Do not apply it so thickly that it squeezes up between the joints in the mosaic, because it can yellow as it dries. Wipe away any that you accidentally smear on the face of the tiles.

There is also a permanent white craft glue suitable for exterior use. Do not use it as a fixing medium when you are using the indirect method, because it sets so fast that you cannot subsequently remove the backing paper.

Fixing Equipment

A variety of tools are required for fixing mosaics. Each different type of job requires its own special tools. Here is a brief description of each tool, and you will find more detailed. explanations in the descriptions of mosaic techniques.

GLASS CUTTERS

These are useful for scoring straight lines, particularly on gold or silver tiles where mistakes can be expensive. They are also useful for cutting stained glass.

PAINTBRUSHES

For gluing, sealing, and painting, it is helpful to have a range of sizes. Stiffer, rather than softer, bristles are better for gluing.

TROWEL

For mixing adhesive, a flat-ended trowel gives you easy access to the edge of the bucket, which would be more difficult with a curved trowel.

STRAIGHT EDGE

Use a length of timber that is truly straight, in combination with a level, to check the condition of large surfaces.

TILE NIPPERS

These are essential for the mosaicist.

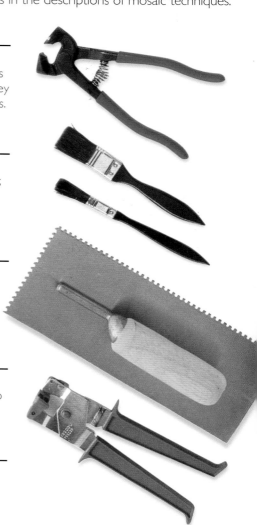

CARBORUNDUM

Use this to abrade uneven areas in a screed or render. This tool helps to create a flatter surface. For finer surfaces use a finer grade of Carborundum.

HAMMER AND CHISEL

These are used to remove tiles that have adhered to a substrate. Use one that has a cutting blade appropriate for the size of tile you are removing.

CARPENTER'S LEVEL

Few walls or floors are truly flat. If you are making a mosaic based on straight-laid tiles in which the grout lines run through in both directions, every inconsistency in the surface beneath will be reflected. You can at least ensure that your mosaic is straight by using a level.

BUCKETS

Whenever you fix mosaic, you will need at least one bucket to hold the water for cleaning your tools and rinsing out your sponge. For larger projects, they are also essential for mixing grout and adhesive.

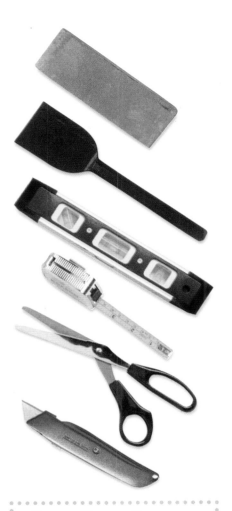

OTHER TOOLS REQUIRED

Tape Measure
Screwdrivers
Craft Knife and Scissors
Dustpan and Brush

Grouting Equipment

Fixing and grouting are part of the same process, but grouting requires a range of special equipment. The larger the mosaic panel that you are making, the more you will appreciate how these tools will speed up your work.

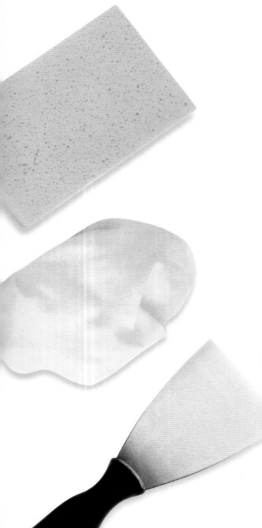

SPONGE

A large but fine-grained sponge is an essential mosaic tool. Adhesive manufacturers often produce very good ones. Do not leave them in water in which cement has dissolved, because cement ruins good sponges remarkably quickly.

RAGS

Keep a collection of lint-free cloths, which are always useful in cleaning up mosaic after grouting.

SPATULA

Useful for any work on a very small scale, or when working on a curved surface.

WALLPAPER SCRAPER

This is an ideal tool for mixing grout. The flatended blade allows you to get right to the bottom of any bucket. They are inexpensive and easily available.

GROUTING SQUEEGEES

These come in a variety of sizes and weights. For small projects, a cheap squeegee from a hardware store is adequate. For small panels and uneven surfaces, it is often just as easy to push the grout into place with your hand as it is to grout with a squeegee (you should wear rubber gloves to do this). A good basic squeegee is strong, fairly cheap, and long-lasting. Its flexible rubber blade makes it slightly easier to use than the cheaper, more rigid ones. Although they are expensive, it is worth spending the money. Using one of these, you can grout a wall in about a quarter of the time it takes with a rubber-bladed squeegee.

GROUT

Grout is a mixture of cement and fine sand. Manufacturers produce grout for both wide and narrow joints. Wide-joint grout uses a coarser grade of sand and is easier to use and less slimy than that used for narrow joints. Grout is widely available in a variety of colors, and admixes can be added to white grout to produce less traditional colors. Epoxy grout is more water-resistant than normal grout and is often recommended for outdoor use. It is more difficult to use than cement-based grout, and considerably more expensive.

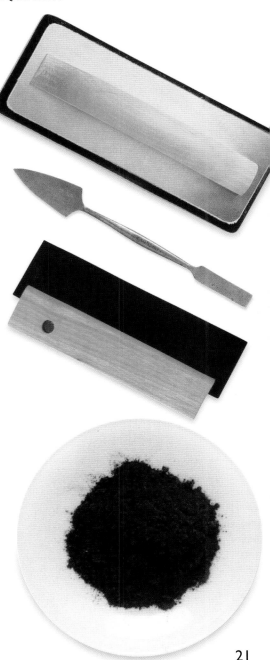

21

Drawing and Designing Equipment

Not all of these tools are necessary for the beginner, but as you tackle larger and more ambitious projects you will find uses for many of them.

BROWN PAPER

This is the paper on which all indirect method papered-up mosaic is laid. Make sure you use a heavy grade of paper 90 gsm is ideal.

LAYOUT PAPER

This is drawing paper that is thin enough to allow you to see through it. It is useful for working out designs.

COLORED PENCILS

Select a range of crayons or colored pencils that represent the colors you will be using in mosaic.

CHARCOAL

Because you can easily rub charcoal out with the back of your hand, it is invaluable when you are creating designs.

TRACING PAPER

It is easiest, although more expensive, to use it from a roll where you are not limited by the paper size, rather than in sheet form.

COMPASSES

A beam compass is useful for drawing large circles for decorative circular panels. If it is beyond your budget, you can do a reasonable job with a long nail and some string to which you attach a pencil.

CRAFT KNIFE

This is an invaluable tool both in the workshop and when you are drawing designs.

PENCILS

It is useful to keep a variety of both hard and soft pencils.

RIGHT ANGLE

If you are making a decorative feature in a field of sheeted-up mosaic, it is essential that the edges are straight and that the corners are at true 90 degree angles to one another.

Safety Equipment

Whenever you work with sharp tools, chemical preparations, or materials that can shatter, as you do in mosaic making, it is essential to take safety precautions. This is especially important if you try to encourage friends or children to share your enthusiasm. It is easier to get others to take safety seriously if you do so yourself.

BUCKETS

Do not clean your tools or other equipment in a domestic sink or pour the remnants of your fixing materials, such as water containing grout and adhesive, down the drain.

RUBBER GLOVES

Wear gloves whenever you use cement, cement-based adhesives, or grouts containing cement.

KNEEPADS

Protect your knees with kneepads, although some people find them uncomfortable. A good alternative is a small rubber or polystyrene cushion. This will also protect your knees from the damp of the floor.

MASK

Always wear a mask when cutting mosaic. If you sit in a sunny spot while cutting, you can see the amount of dust that is thrown up every time you fracture a tile. If you inhale this over long periods, it will affect your lungs. The dust from marble tiles is especially harmful.

GOGGLES

It is advisable to protect your eyes from tiny splinters of material that may be thrown up when you are cutting. If you already wear eyeglasses with reinforced plastic lenses, it is not generally necessary to take further protective measures.

23

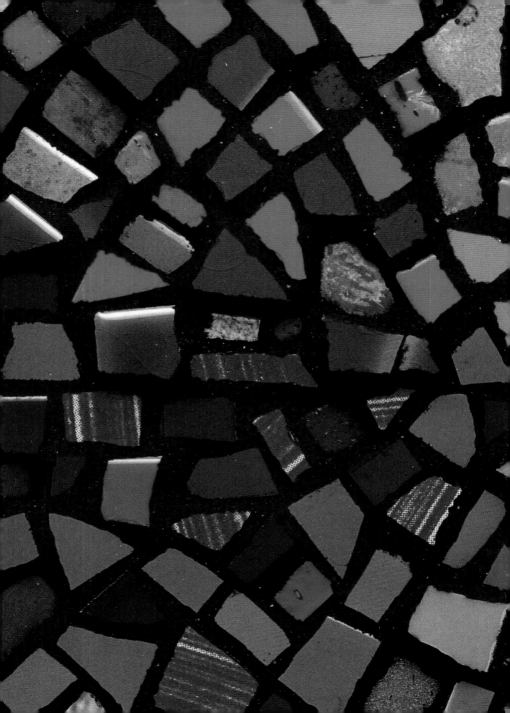

Before You Start

You don't need much to begin your first mosaic, just a good simple design, some old tiles, and the minimum of tools. Soon you'll discover that mosaics are an addictive, absorbing, and inexpensive craft, immensely enjoyable to make, and accessible to all as stunning results can be achieved by using relatively simple techniques. But beware—once you have embarked on your first mosaic you may soon be hooked!

Working Out Your Design

Once you have started to work in mosaic, you will begin to notice mosaic-like qualities in all sorts of ordinary objects around you. When you are looking for visual images to inspire you, a useful starting point might be anything you have collected because it appealed to you.

This might be anything from postcards to pebbles from a beach. Try to work out why you are attracted to these objects—because of their color, design, shape, or texture? Once you know why something appeals to you, it will be easier to produce a working design from it. For instance, if the pebbles appeal to you because of their soft, natural colors, then consider making a mosaic from pebbles or from similar colors of riven marble. If the postcards appeal to you because of their bright colors or simplified designs, you could work on a panel for your kitchen or bathroom that uses bright sea-and-sand colors or recreates a beach scene.

The most compelling creative impulses come from something that stimulates you, and that makes you feel driven to investigate further. Don't pursue something just because you feel it ought to be interesting to you. If it doesn't genuinely excite you as a theme or as subject matter, that lack of interest may well come across in how you work, and the piece will be less appealing as a result.

THE NATURAL WORLD

No matter how many times you look at a subject, if it genuinely interests you, you will have something new to bring to it. Subjects don't get exhausted by being looked at again and again; they often become richer and more interesting. You start to see things in them that you previously missed, or having dealt with the subject in mosaic, you start to see the thing itself in a new way. Fish are a popular subject in mosaic, probably because of their scales, which suit interpretation in mosaic. Birds are another recurring theme, as their feathers can be treated in a very naturalistic way by mosaic tiles.

Make sketches of objects to get a feel for the shapes and develop ones that you find interesting.

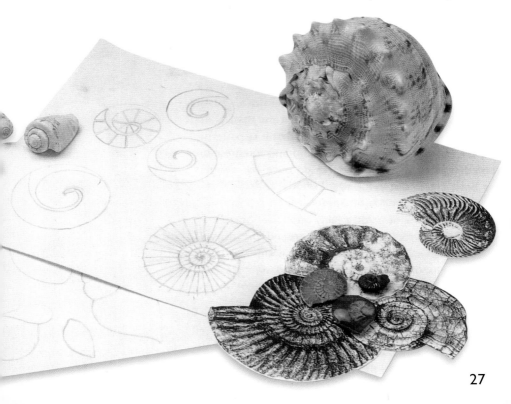

TEXTILES

Textiles are a rich source of inspiration, and a relationship between mosaic and woven fabrics is not new; ancient examples of Coptic weaving show the influence of traditional mosaic patterns in carpet borders. There is a clear link between stitches and tesserae. Repeated patterns are also common to both mosaic and textiles.

ABSTRACT IDEAS

You may find, though, that the thing that really drives you is not a particular subject matter, but the mosaic-making process itself. There is an immense amount of interest to be derived from simply investigating what the medium enables you to do. Allow yourself to be led by the colors or textures of the tiles. Play around with the different effects created by reflective and matte surfaces, or with cutting contrasts. Search out unusual objects or abstract images that you can turn into patterns or color themes for a mosaic panel or border.

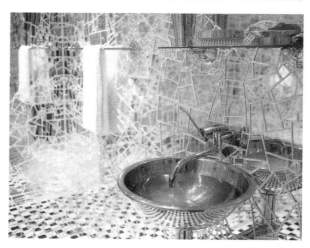

Above: *Mirrored bathroom by Fran Soler.*

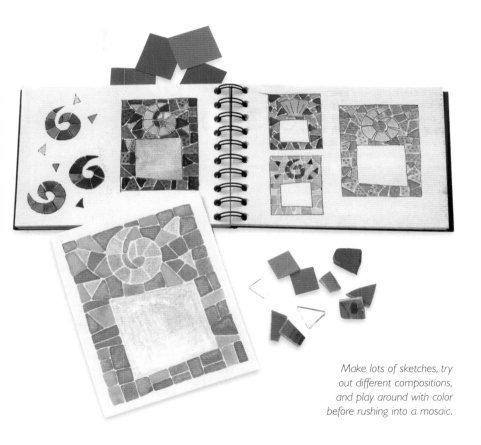

Make lots of sketches, try out different compositions, and play around with color before rushing into a mosaic.

CONCLUSION

You will find that mosaic itself can provide a rich source of inspiration for you when designing a new mosaic. Try looking through art and architectural books at your local library, subscribing to craft magazines, or visiting your nearest museum. Finally, be alert to the many mosaics—old and new—that may decorate shops, offices, and public buildings in your area.

Choosing Your Colors

Mosaic is unusual among creative mediums in that it does not really allow for color mixing. The mosaic palette is fixed by the color of the material and you will need to design your work with this fixed range of colors in mind. One consequence of having a fixed palette is the need for stylization. The results of working within these constraints can be pleasingly bold, but they can also result in designs that are far from subtle in effect.

COLOR WHEEL

This shows the traditional way of considering colors. The primary colors are red, yellow, and blue, and the secondary colors are purple, green, and orange. In mosaic you can create an impression of a color, such as orange from red and yellow, by intermixing tiles but the optical effect works only from a distance.

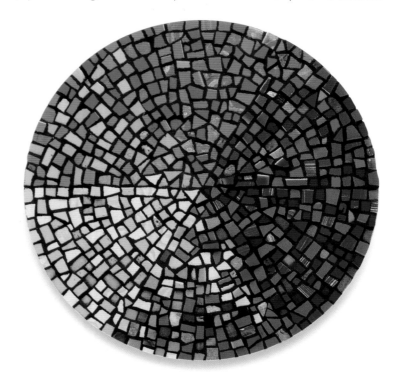

COMPLEMENTARY HUES

If you have a plain background area to fill, you can avoid boring areas of flat color by mixing different hues, such as the red and brown here, provided that you keep the tones close.

CONTRASTING HUES

The yellow pieces in this mosaic contrast with the blue background tiles in both hue and intensity, but a visual link is made because of the gold veining running through the vitreous blue glass.

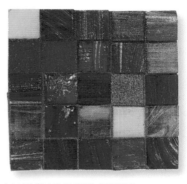

COMPLEMENTARY TONES

Although the hues in this mosaic are distinctly different, the tiles fuse together because they are close in tone; they carry the same degree of darkness.

VARYING INTENSITIES

The yellow in this piece illustrates a distinct difference in intensity of color. The yellow is much brighter than the other colors and stands out dramatically.

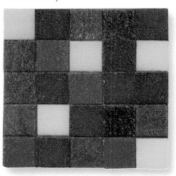

SIMILAR TONES
This mosaic uses a relationship of closely toned hues, but this time the degree of lightness is equal, giving a harmonious effect.

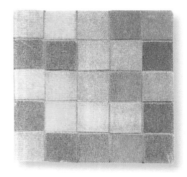

SIMILAR INTENSITIES
The white tiles are much brighter than the other tiles in this piece, but in this case they make the mosaic look fresh and lively.

MOSAIC PALETTE

The colors that you can obtain in vitreous glass and smalti range from somber to very bright. Extra interest can be gained by using gold or silver or gold-veined vitreous glass tiles. The palette of colors is rather restricted, so it is important to consider the color relationships within your mosaic. Colors can be classed as either warm or cool and a warm-colored motif will stand out effectively against a background of cool colors.

COLORED GROUT

Simply changing the color of the grout will dramatically affect the overall feeling of the mosaic. Since the grout itself and the spaces in between the tesserae play such an important role in the mosaic, it is important to consider the grouting while thinking about the design. White grout can be very harsh, particularly when used to fill a mosaic of dark or bright colors. The bright white tends to draw the eye to the gaps rather than the colors, but works very well for pale mosaics, including work with mirror tesserae. Dark grouts enhance the color of the tesserae. It is very effective for highly colored mosaics, but can dominate pale colors. Experiment with small batches of grout. Try coloring grout with dyes, pigments, or paints to achieve maximum contrast or subtle variations.

Top: *Pale grout appears to lighten the colors of the mosaic*
Above: *Darker grout with the same color tesserae produces an entirely different result*

The background to the starfish panel has been grouted using a color that draws it together. It allows the starfish to be read as a clear image against a flickery background.

The grout color has helped to give clarity to the piece. The fish panel demonstrates how color can balance form. The shape and density of the fish is compositionally balanced by bright color of the weed.

Types of Tesserae

The various types of tesserae available for mosaic work have specific characteristics. This section is a guide to tesserae, looking into their suitability for different locations as well as the sizes, availability, and relative cost of the materials.

SMALTI

These are the classic mosaic material—small, thick, rectangular chunks of handmade Italian glass. Being handmade, smalti is expensive, but comes in a vast range of colors and also possesses amazing light-reflecting qualities. The sizes vary slightly, usually approx $2/_5 \times 3/_5$ inch (10 × 15 mm) and are of fairly uneven thickness. This makes them unsuitable for jobs where a flat surface is required, such as floors, but it is that same unevenness that catches the light and makes a mosaic sparkle. Also, because of the uneven surface, smalti is not usually grouted, the idea being that when the smalti is pushed down onto the tile adhesive, it pushes the adhesive into the spaces, providing a kind of self-grouting. For a coverage of 1 square/foot (30 × 30 cm) you will need approximately $3/_4$ pound (1.35 kg) of smalti.

GOLD AND SILVER SMALTI

Extensively used by Byzantine artisans when making religious icons, these are also handmade Italian glass and have real gold and silver leaf pressed into the tile. These are available plain or smooth and also with a rippled surface. These tesserae can also be used upside down with great effect, because the gold has a shiny green underside, and the silver has a shiny blue underside. Although they are more expensive than regular smalti, even a few pieces used sparingly can add sparkle and transform an otherwise dull mosaic into a glimmering work of art.

VITREOUS GLASS

Also made of glass, these are manufactured in regular squares. The uppermost side is smooth and flat, while the underside is rippled for adhesion. These are an ideal material for beginners, as they are thin, flat, and easy to cut. They also give a flat surface and can be used for all kinds of projects. Vitreous glass tesserae come in a wide variety of colors and can be bought loose or on brown paper sheets.

GLAZED CERAMIC

The range of glazed ceramic mosaic tiles is limited. They are available mainly in blues, greens, and other colors that are considered suitable for swimming pools. They tend to be domed, which makes them difficult to use once they have been cut. The cost ranges from a price comparable to unglazed ceramic to a price comparable to that of glass.

CERAMIC TILES

The range of colors, textures, and patterns of household ceramic tiles is endless. They are cheap, easy to cut, and can be used with great effect. They are extremely versatile but are unsuitable for some projects, such as outdoor mosaics, as they are not necessarily frostproof. You may have some old unwanted tiles hiding in the cupboard that can be used to practice your cutting technique.

MARBLE

Many of the oldest mosaics were made from marble and other local stones. The natural variation within a single color gives marble its unique interest. Traditionally used for floors, it can also be used on walls. However, because it is fairly thick, generally a minimum of 1 cm, it is heavy, making it slightly tricky to fix in place. Unlike other mosaic materials, a single piece can be cut and finished in a variety of ways. Marble is expensive, but not as expensive as smalti.

POLISHED MARBLE

Marble can be polished, revealing its body color through a glassy finish. Polished marble is generally supplied in mosaic tiles known as cubes. These can be purchased loose or in sheet form. When it is in sheets, it is often stuck to the mesh with waterproof glue, so it is safer to buy a mix of marble cubes than to risk being unable to soak the marble off the mesh.

MARBLE RODS

In order to create cubes, marble tiles are first cut into lengths known as rods. These can be cut down further with a marble saw (a large piece of equipment, not generally needed by the amateur mosaicist) or more usually with a pair of tile nippers or a hammer and hardy (see page 58). These lengths of marble can also be used as they are, offering a contrast of scale. They are a cheaper way of buying marble.

MIRROR MOSAIC

Mirror mosaic can be purchased in two forms. Fabric-backed sheets are supplied with a special adhesive that does not interfere with the silvering on the back of the mirror glass. Bought like this, the tesserae are relatively inexpensive. It does have a disadvantage: in order to produce the material, a single sheet of glass is cut in two directions with a grinding wheel, which leaves behind a ground score mark. When you use mirror tiles in sheet form, the score lines give an impression of grout lines.

STAINED GLASS

Stained glass can be used in mosaic. It is easier to find an application for opaque stained glass, but even transparent glass can be used in some projects. Cut the glass into strips with a glass cutter, and cut into mosaic pieces with tile nippers.

COLLECTED OBJECTS

Broken plates, buttons, beads, bottle caps, stained glass, mirror, shell, pebbles. Anything that you find that can be broken up and arranged in a pattern has the potential to become part of a mosaic. Broken pottery is a great source of mosaic material, but is unlikely to be frostproof, so not suitable for outdoor use and also not hard wearing nor strong enough to be used on floors.

37

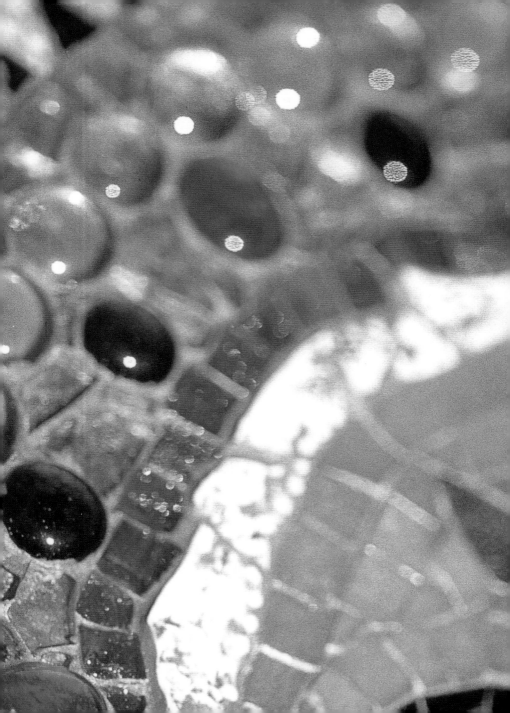

Techniques

A number of special tools are used in mosaic making to cut the materials available to the mosaic artist. If from the outset the cutting techniques are fully understood and the tools are handled correctly, all the materials used in the projects should be cut with facility and under the control of the artist. It is, however, advisable to wear protective eye shields and dust masks at all times and gloves when cutting mirror and glass.

Adhesive Techniques

Adhesive is the medium with which you fix the tiles. The ones most frequently used by interested amateurs are those based on plastic (such as white craft glue), which are easy to use directly and tend to be less messy than those derived from sand and cement (see Direct Method, pages 66-69).

It is worth familiarizing yourself with sand-and-cement-based adhesives, however, since they are much more adaptable than plastic-based ones. They are simple to use on vertical surfaces, or even on a ceiling, because they have a great deal of grip. For this reason, they are commonly used for architectural mosaics. They also have body, which allows you to even out the differences between thicker and thinner tiles. Remember, it is essential to wear rubber gloves when working with cement-based adhesives.

TOOLS AND MATERIALS
❑ Grouting squeegee
❑ 1/8 inch (3 mm) notched trowel
❑ Flat-ended mixing trowel
 for mixing adhesive
❑ Wallpaper scraper for mixing grout
❑ Bucket
❑ Sponge

❑ Rubber gloves
❑ Small tool
❑ Grout
❑ Adhesive
❑ Board onto which mosaic
 will be fixed
❑ Tiles

I Mix the powdered grout with water to a fairly stiff mix and put to one side. Choose a cement-based adhesive suitable to the job. Check the manufacturer's recommendations. For example, not all cement-based adhesives work well on wood; some require special admixes or that you prime the board first. Mix the cement-based adhesive with water, carefully following the instructions. Once both grout and adhesive are ready, pregrout the mosaic from the back.

ADHESIVES

2 Sponge any excess grout from the back of your piece with a damp. but thoroughly squeezed-out sponge. Clean off with the sponge flat on the mosaic. wiping in a series of broad sweeps. Dabbing at the mosaic will not clean it properly

3 This technique is not necessary in all cases, but it is a useful one to know. Tiles produced by different manufacturers are sometimes of different thicknesses, leaving you with an uneven surface. However, by "buttering" the back of the tiles, you can compensate for any unevenness and thus produce a flat surface. Simply apply extra adhesive to the areas where the tiles are thinner, taking the surface up to the level of the thickest tile.

4 Once the levels have been evened out, apply adhesive to the board with a notched trowel. Flatten the trowel slightly to apply adhesive, but use it at a 90 degree angle to remove any excess. Try to make sure there is an even quantity across the whole surface. If some areas don't have enough adhesive, the tiles will not stick.

41

5 Carefully, without folding or flapping it, turn over the mosaic panel. Aligning the corners with the corners of the board, place it in position. Give the back of the mosaic a gentle tap to ensure that it is all in contact with the adhesive.

6 Wet the back thoroughly with a sponge, and leave to absorb the moisture for a good five minutes. If the paper has not turned dark brown or there are paler patches evident on the paper, continue wetting.

7 Once the paper has changed color to a really dark brown, peel it off. Remember to pull the paper back on itself, not upward, or you may displace tiles. If any tiles should accidentally come away, simply replace them in their original position. If it looks as if there is no adhesive in the gap, put a small quantity on the back of the tile before placing it in the hole.

8 Once the paper has been removed, sponge the mosaic from the front. It need not be perfectly clean, but make sure there are no lumps in the grout before it dries. Once the mosaic has had time to dry and is thoroughly set, regrout from the front.

Andamenti

Andamenti is a term used in mosaic making that refers to the coursing of the grout lines, the way in which the flow of the lines helps to give form to the work. There are many different andamenti techniques, many of them named (see Opus, pages 101-104, for more information on the frequently used ones).

Andamenti is about introducing a system to your work. Once you have decided how the andamenti will flow in your piece, it is important to be consistent. Like all systems of rules, it may provide restrictions, but it also allows a kind of freedom within its boundaries. This panel of pigeons in a pear tree (see following pages) demonstrates the ways in which andamenti can be used to enhance your work.

The panel is laid by running lines of tiles across the design. These tiles stay in line even when the design elements change, giving a feeling of harmony. Some systems of laying tiles are lively and add a feeling of movement to a piece. The purpose of this system is to give an impression of calm.

Occasionally you can emphasize a particular design feature by breaking your own rule. This leaf is a case in point. The upper part of the leaf runs into the main grout lines. You can see the way the tiles are broken so that the upper side of the leaf and the background express the same line. However, the left side of the leaf breaks this rule and has a more expressive, leaflike quality by doing so. The way the tiles suddenly run at a different angle makes the leaf look genuinely veined.

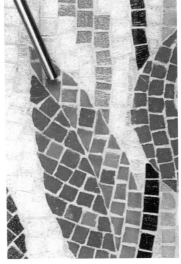

Here the neck of the pigeon runs into the grout lines of the background at an angle, helping to express the plump form of the bird. Just to the right of the pigeon is another leaf, which makes an interesting comparison with the top picture. Here the lines run straight through and the leaf is less animated.

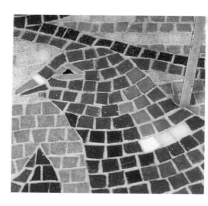

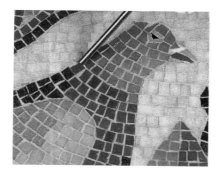

These bright patches of color work because the eye makes sense of areas of intense brightness around the bird's neck. Once again, note how the changing direction of the andamenti help to describe the form of the bird.

The feathers on the pigeons' wings employ the same system of lining through the grout lines. This helps to create an authentic impression of the way feathers fold up against one another. Note the way in which a feeling of form is given by minor variations in tone.

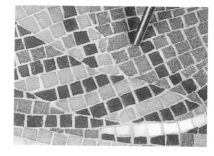

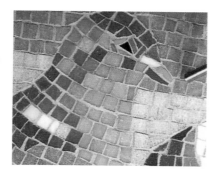

This bird's head is the most impressionistic element in the piece. The grout lines run through so the form is created by variations in color. The bird's beak breaks the andamenti system, giving emphasis to this key feature.

This picture gives an impression of the way in which most of the background is laid. However, the structure, the bare bones of the design against which the rest is defined, is the heavier, darker tones of the branches. To give these further emphasis, they are laid in a way that breaks the overall andamenti pattern.

The main field of this design is laid in lines that run all the way through the objects, from side to side. This is not a typical mosaic way of working, and there is no special name for it. It gives a flat, harmonious quality to a finished surface. If you are going to work like this, you have to be very disciplined about making your cuts run along the lines, and it can take a lot of experimentation to find the most elegant way to do it.

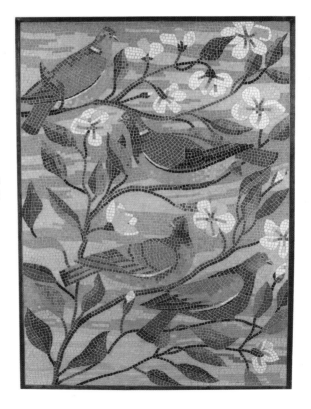

Backgrounds

Mosaic backgrounds can be laid in an infinite variety of ways. How the tiles flow around an image alters the way in which you read it. If the background tiles follow the direction in which the central design is laid, it can give quite a lively sense of movement.

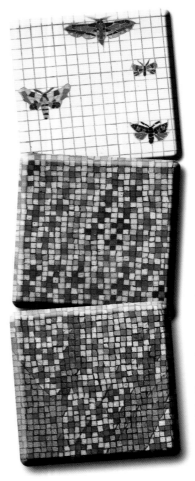

This is probably the simplest way of dealing with a background, and it means you can use factory-prepared, sheeted-up mosaic. In this instance, the stark, straight laid, simple background actually emphasizes the naturalistic feel of the treatment, and the grout lines help to accentuate the veining of the moths' wings.

This design builds an interesting background from a simple repeat. The tiles have been quarter-cut and are arranged in vertical and horizontal lines, but tiny elements of distortion have been introduced to enliven the effect. The design has been given complexity and interest by the variety of slight color changes within the repeat, and by the use of roughly cut tiles, which means that the eye does not immediately grasp the pattern. A pattern without much variation will not hold our attention for long.

This panel continues to experiment with the pattern repeat, but introduces a new idea of subdividing areas through more strongly differing colors. The effect gives the mosaic a layered look.

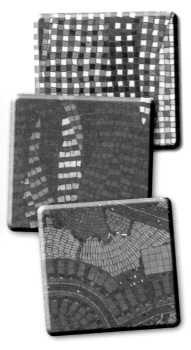

1 Here, the panel illustrates how you can give interest to a repeating pattern through minute distortions. The curved lines that the color changes follow, and the wavy distortion created by using tiles of slightly differing shapes and sizes, make the basic geometric pattern appear to flow like fabric.

2 This mosaic is laid along one, essentially horizontal, undulating line. The tonal closeness makes the background quite subtle, but the distortions and variations of vertical shapes give it interest. Some silver mosaic has been used to introduce a reflective element to the design.

3 This whole piece was made with a view to pattern, line, and tone. A variety of laying techniques and changing angles have been used, making this mosaic playful and experimental, and therefore enjoyable to look at.

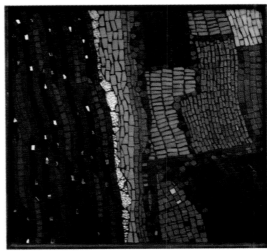

Right: *In this panel the whole design, which is an aerial view of a coastline, is treated with equal interest and the result is a very rich feel to the mosaic.*

Borders

Some borders are geometric; others take a freer approach like the one shown here (left). The process of creating a traditional, repeating rope border illustrates many of the fundamental rules involved in making borders. The design is up to you. This border is designed to fit in with sheeted-up tiles.

It is perfectly possible to make a border that has no repeats. You can cut out a long strip of paper, draw your design onto it, and stick it directly to the paper. The border can be subdivided for fixing once it is completely laid in place. It is necessary to number the sections and make a key drawing, otherwise it may not be obvious how to put the border back together again. There are no such problems with a repeating border though. This section shows how to make one.

TOOLS AND MATERIALS

❑ Ruler
❑ Pencil
❑ Charcoal
❑ Crayons
❑ Layout paper
❑ Brown paper
❑ Water-soluble white craft glue
❑ A selection of mosaic tiles

I Whether or not you are designing your own border, one decision is critical, and that is the size of the tile you are using. This is known as the tile module. In order to make a design flow elegantly, and to minimize cutting, it is a good idea to base the width of the border on the module. In addition, if your border is designed to fit in with sheeted-up material, you need to make it the exact width of

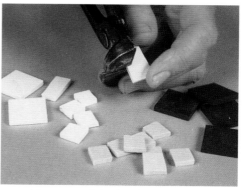

a series of tiles; in other words, the top and bottom of the border must be located at the exact spot where joints run in the sheeted-up material. Otherwise, you will have to cut tiles on the sheet, either on the inside or the outside.

2 Once you have selected the tiles you wish to use and have decided on the tile module, measure out an area that matches sheet joints both horizontally and vertically. Divide the area into lines that represent the coursing of the mosaic tiles. Divide this into four sections representing the places where the high and low points of your design will fall.

3 Draw the design freehand onto the paper; use layout paper, so you can redraw the design if necessary without having to take measurements all over again. Sketch on the paper with charcoal initially, as this is easily erased if you make a mistake.

4 Once you have established the basic shape of the border, redraw it, showing the way in which you plan to course the tiles. Remember, the tiles must meet each end at exactly the same spot, or the border will not align correctly.

5 Once you have drawn the coursing, check that both ends meet precisely. You can do so by folding the paper over and onto itself.

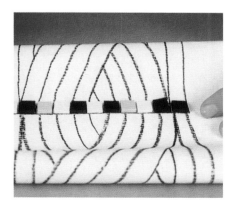

6 Color in your drawing. It is useful to file this away once the mosaic is completed, keeping it as a template in case you want to use the same border again in the future.

7 Draw the design onto brown paper. Because the design is geometrically constructed, it offers a further potential repeat break in the center. If you have not made the length of the border match an even number of tiles on a sheet; using this repeat will mean having to cut tiles on the sheeted-up material.

8 Following your colored drawing, stick the tiles to the brown paper. This is your border section. You can proceed with grouting and fixing it in place by the indirect method.

9 Corners obey the same rules as borders and can be made following the same principles.

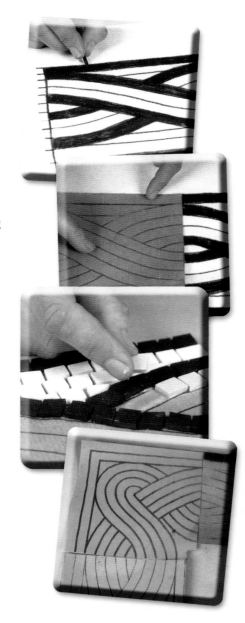

Casting

It can be hazardous to place an uneven piece on a floor. This technique is ideal when you need to produce something flat for practical reasons but want to use materials of different depths. By sticking the mosaic to paper, you automatically create one reasonably flat plane.

TOOLS AND MATERIALS
- ❏ Screwdriver
- ❏ Scissors
- ❏ Sponge
- ❏ Paintbrush
- ❏ Rubber gloves
- ❏ Grouting squeegee
- ❏ Wallpaper scraper
- ❏ Flat-bed squeegee
- ❏ 2 large boards
- ❏ Casting frame (4 pieces of batten, 8 screws, backing board)
- ❏ Water-soluble white craft glue
- ❏ Petroleum jelly
- ❏ Brown paper
- ❏ Charcoal
- ❏ Expanded metal lath (EML) or chicken wire
- ❏ Tiles, terra-cotta tiles, marble cubes, or any selection of materials you wish to use
- ❏ Plastic sheeting
- ❏ Cement
- ❏ Sand

I Make or buy a casting frame. To make one, screw four pieces of batten to a backing board. Do not use glue because it is essential to be able to dismantle it later. Ensure a tight fit between the battens so there will be no leakage from the joints.

2 Cut a piece of paper slightly smaller than the internal dimension of your frame. The gap you leave will be at the edge of the tiles, and you will fill this with cement.

3 Draw your design onto the paper with charcoal. The charcoal can be rubbed off easily if you need to amend the design slightly.

4 Stick the mosaic to the paper using a water-soluble white craft glue, diluted 50:50 with water. Ensure that the gap you leave between the tiles is similar throughout. You may need to cut tiles to accomplish this. When it is complete, let it dry thoroughly.

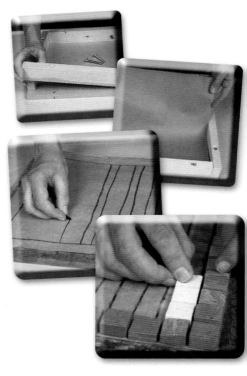

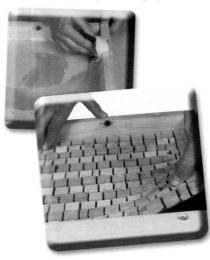

5 Use a sponge to spread petroleum jelly evenly and thoroughly over the inside of the frame. This acts as a release agent, ensuring that the finished work will not stick to the surface of the wood.

6 Place your mosaic into the base of the frame, paper side down. Do not bend or fold the paper as you transfer it, because this may cause tiles to peel away. If this occurs, reglue and leave to dry before pregrouting. This is your last chance to check the spacing between the tiles. Once the grout is applied, it will not be possible to make any changes.

7 Terra-cotta absorbs water from cement, causing it to crumble and not set properly. To prevent this, wet any terra-cotta tiles by brushing water over them.

8 Pregrout. Mix a cement slurry (a creamy mixture of cement and water) and apply it with a squeegee to the back of the mosaic. Push it into all the joints, and scrape off any excess. Always wear gloves when working with cement.

9 Mix together one part cement to three parts sand. Add water until the mixture is firm but workable, with no water running out of it. Apply a layer of this to the back of the tiles using a wallpaper scraper. About halfway up the frame, smooth the mixture.

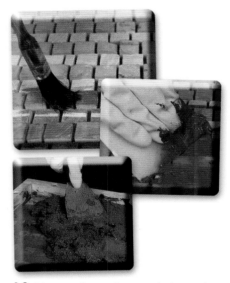

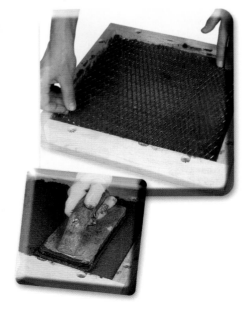

10 Place a piece of expanded metal lath (EML) or chicken wire on top of the sand and cement mix. This will give your slab strength. Apply a second layer of sand and cement until it reaches the top of the frame. You should not be able to see any EML. If you can see any, remove the sand and cement, relay the EML, and cover once again.

11 Smooth down the surface with a flat-bed squeegee. It can sometimes be useful to inscribe information into this wet mix, such as the ambient temperature of the workroom or details of how you made the piece. This is especially helpful if you are doing something unusual, using a different kind of sand, for example, and want to replicate it later.

12 Wrap the slab in plastic sheeting. Leave it to set for at least a week.

13 Unwrap the slab carefully. Unscrew each batten and remove it. When they are all off, place a board underneath and a board on top of the mosaic, sandwich them tightly together, and turn over. Be careful to maintain a tight grip while you do this. Remove the board. You should now be able to see the paper.

14 Use a sponge to wet the paper thoroughly. Leave it for ten minutes to absorb the moisture, checking periodically that it is not drying out.

15 Peel the paper carefully away from the face of the mosaic. Try to keep it in a single piece, peeling from one corner to the center, then turning the slab around and working in from the other corner.

16 Regrout the front of the mosaic with a cement slurry made up as before. Make sure all the tiny holes are filled.

17 Wet a clean sponge and squeeze out as much water as possible. Use this to clean your slab. Rewrap the slab in plastic and leave for two weeks to dry. The slab can then be laid in the garden.

Motifs

A central mosaic motif can be used to make a plain floor more lively. The key issues in making a central motif work in a mosaic floor are ones of color, scale, and practicality. It is essential to get the proportion and emphasis right.

I It is helpful to take the measurements of the area for which you are planning a mosaic. Using this information, produce a scale drawing of the room, and sketch your design onto the drawing. A design that works well on a piece of paper may seem small in the context of a room. The fish design shown at this scale is obviously not large enough to make much of an impact.

2 If your feature seems too small, redraw it to a larger scale. It might seem time consuming to draw and redraw the design, but time spent at the planning stage speeds up production time and ensures pleasing results.

TOOLS AND MATERIALS
- ❏ Ruler
- ❏ Pencil
- ❏ Crayons
- ❏ Layout paper
- ❏ Brown paper
- ❏ Water-soluble white craft glue
- ❏ A selection of mosaic tiles, sheeted-up for the floor and loose for the motif

3 Most central motifs benefit from the addition of a border or decorative surround. A simple linear border like this one increases the visual impact without significantly increasing labor. A circular border, although very effective, would be much more labor-intensive to produce, because it would require a lot of cutting.

4 Select the palette of tiles you wish to use, keeping in mind your choice of background colors and the color of the grout.

5 Measure a piece of brown paper so that it fits precisely with the sheeted-up tiles. Draw the central motif onto brown paper, enlarging it if necessary (see page 122). Where straight lines of tiles run through the whole design, it is helpful to use a straight edge or long ruler to draw guidelines, to prevent uneven gaps or crooked sections.

6 Lay the decorative element of the design first. When so much of the design is made from sheeted-up material, accuracy in cutting around the cut-piece motif is even more important.

7 Once the design is complete, recheck the accuracy of your straight lines before fixing the mosaic in position. It is essential that any inaccuracies are sorted out on paper before you fix, because troubleshooting at a later stage is much more difficult.

Cutting Techniques

Not all materials cut in the same way. This section explains how and why they fracture in the way they do, and shows how best to make them do what you want. You will know you have mastered cutting when your piece looks as if it was easy to make. See the Gallery (see pages 216-219) for examples of work that demonstrate all these cutting techniques.

CERAMIC AND GLASS MOSAIC TILES

1 A simple and effective way to use ceramic and glass mosaic tiles is to quarter-cut them. Place the nippers on the edge of the tile, at 90 degrees to it, and press, holding the tile in your hand as you do so. Do not cut tiles over your mosaic, because fragments may stick to the board or paper and prevent proper bonding.

2 You can also experiment with more ambitious shapes. If you need a precise shape, it helps to sketch it onto the tile with a pencil. Place the nippers on the edge of the tile at the angle you need. If you want a curve, you may have to make a series of cuts, "nibbling" the tile. Remember to cut away from your curve, rather than into it.

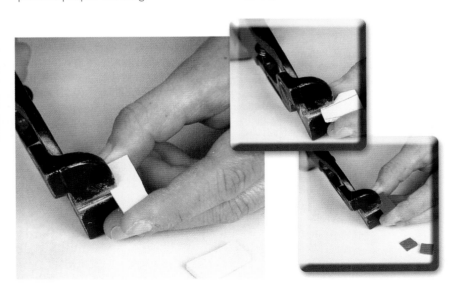

MARBLE

I Place your tile nippers centrally along the line you wish to break and exert sharp pressure. If you try to cut too slowly, this can make the material crumble.

2 Riven marble is created by a cutting process. Place a marble cube within the jaws of the nippers and exert sharp pressure. By cutting it in half, you create a rectangular rather than a square piece. Continue nipping down until you reach the desired shape.

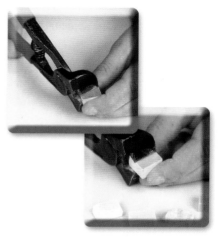

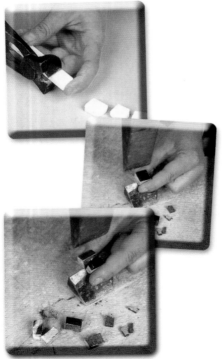

3 Marble is available either in cubes or in rods. They can be cut either with tile nippers or with a mosaic hammer. If the nippers will not open wide enough to take the depth of the marble, remove the spring, which is not essential for the nippers to function.

4 The quickest way to make a simple, straightforward cut is with a hammer and hardy. The hammer ends with a pointed blade and is used in conjunction with a chisel-type blade, stuck in a log, which is known as a hardy. To cut, place your tile over the hardy so the blade expresses the direction you want the break to go in.

5 Do not swing the hammer. Let it fall with its own weight onto the marble. If you cut too heavily, the two blades will meet and blunt one another.

MICROMOSAIC

This requires immense patience, lots of practice, and extremely fine cutting. Ensure that you have the sharpest nippers available, perhaps even reserving a pair to use only for micromosaic.

I Tile nippers have two lugs to which the spring is attached. These determine the space between the blades and so prevent them from blunting. Micromosaic may require thinner pieces than this gap will allow you to cut. You can narrow the gap by filing down the lugs. When cutting from a large piece, start from the side.

2 Once it has become smaller, you have to put the tile nippers right over the top of it or your cut will not be accurate enough.

SMALTI

Smalti comes in different grades, the lowest of which looks a bit like recycled glass and is difficult to cut accurately. Most commercially available material should be of better quality, but if you have problems making fine cuts, then try cutting from the top rather than the side.

I Smalti can be cut either with a hammer and hardy or with tile nippers. Tile nippers are more practical as you don't have to keep moving between your workbench and the place where the hardy is set up. The fragments created are needle-sharp and dangerous. Clear away the glass dust with a brush, not with your fingers.

GLAZED CERAMIC TILES

When cutting across the whole of a ceramic tile, you may find that the cut tends to curve. If this is a problem, you could use a tile-cutting machine. The curves do have their own charm though. If a material has a particular characteristic it is often rewarding to use it.

1 Although glazed ceramic tiles can be cut with tile nippers, it is sometimes useful to cut a tile down to a more manageable size using a large tile-cutting machine, as shown here, or with the score-and-snap tile cutters available in most hardware stores. The principle is the same for both tools. First, score the tile.

2 Keeping the tile centered on the line you wish to break, gently but firmly press the handle. It will take some practice to get the feel of the pressure you need, but using up broken tiles should not be much of a problem to a mosaicist.

Cutting Shapes

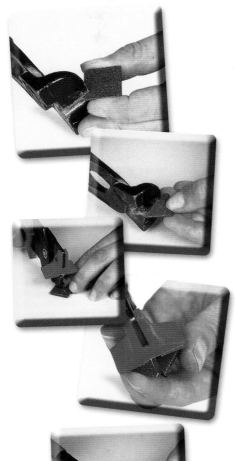

TRIANGLES

1 When you cut from the corner across a tile using nippers, you are likely to produce only one workable triangle, rather than two, and this one is likely to require further "nibbling" into shape.

2 Although your initial cut is made from the edge, for further trimming you can place the nippers right over the area you wish to cut. If you begin by putting the nippers too far over the tile, you are likely to shatter it entirely.

3 More accurate triangles can be made using a glass cutter. This one has a scoring wheel and a snapping mechanism. Score the tile from corner to corner, pressing hard. If you do not press hard enough, you will have to repeat the scoring process.

4 Place the mosaic tile so the score line runs along the shaft of the glass cutter. Press gently but firmly. If you are too timid, you may crumble the corners off the tile.

CIRCLES

Everything you cut is produced from a series of small straight lines, even circles, as shown here. "Nibble" the edge of the tile away to create the circle.

Design Techniques

This section describes the processes involved in producing a design and working from a drawing (for the processes involved in making this item, see Adhesive Techniques, pages 40-42). Producing a working drawing is helpful in all mosaic making.

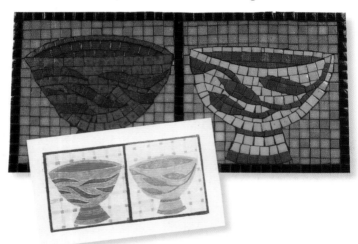

TOOLS AND MATERIALS
❑ Ruler
❑ Pencil
❑ Crayons, colored pencils
❑ Layout paper
❑ Brown paper
❑ Water-soluble white craft glue
❑ A selection of mosaic tiles

bold and graphic. Simplicity and stylization work well in mosaic. The fractured nature of the tiles and grout within any mosaic image means that there is always plenty going on, even in the simplest design.

1 Draw your design on layout paper. Because this paper is translucent, if you need to make amendments you can simply copy from a drawing placed beneath a fresh sheet. Do not be frightened of making your drawing

2 Select a palette of colors. In this design, the aim is to keep the bright, lively bowls in the foreground, setting them against a subtle background. It would be possible to contrast the foreground and background treatments by laying the bowls against a single color, but that would not create any tension between the two areas, and the bowls would be the only point of interest.

3 Match your colored pencils to the colors of the tiles you have selected. Try to make accurate matches.

4 Draw the design using colored pencils, matching not only the colors but also their degrees of intensity. This can give you an idea of how well the design balances. If you feel your selection gives too much weight to one area of the composition, introduce another intense area to balance it.

5 Make a tracing from your completed drawing so that you can reverse the design. Even if a design works at first, it may not be as effective when reversed. Larger tracings, using subdivisions, can also serve as fixing diagrams or key drawings.

6 Draw the reversed drawing on brown paper. It is always better to work on the matte side of the paper, which provides a slightly more absorbent surface for the glue.

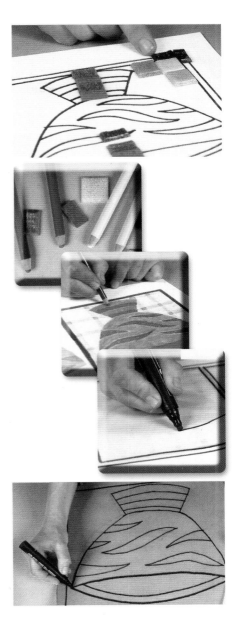

WORKING FROM A SOURCE OF INSPIRATION

Once you are aware of the visual qualities of objects around you, all sorts of unusual objects can provide inspiration. Some things are stimulating because of their color, some because of the composition, some because of their form. Making mosaics trains your eye to look in a new kind of way. The more you do, the more inspiration you will find.

TOOLS AND MATERIALS
- ❑ Ruler
- ❑ Pencil
- ❑ Charcoal
- ❑ Crayons, colored pencils
- ❑ Layout paper
- ❑ Brown paper
- ❑ Water-soluble white craft glue
- ❑ A selection of mosaic tiles

1 This mosaic is inspired by an old piece of polystyrene that was used to pack melons. It has a rhythm and a simplicity that works well as an abstract form, and it makes you think about light and shade. A pleasing pattern is created by slightly displacing a repeated form.

2 Decide on the size of the finished piece, and produce a scale drawing, working out the essential elements of the design.

3 Having decided on a basic structure for the design, you may want to play around with alternative ways of treating it. Running through your design options on paper in advance is quicker than doing so when you are making the mosaic. It is worth taking time at this stage to check that you have made the right color and compositional choices.

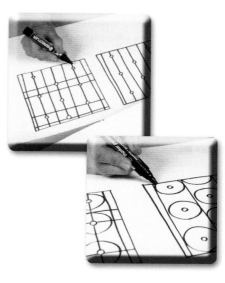

4 Make a selection of colors for your design. Try to find a pencil as close in color as possible to the mosaic tile you wish to use. It is worth investing in a selection of crayons that represent the color range of tiles you use.

5 By coloring a drawing accurately, you can spot any potential problems. You may be able to avoid the colors being too insipid or too strident. If you think your choice of tiles is not working well, reselect and redraw.

6 Once you are confident the design is working, draw it onto your board. Charcoal is useful for this, because it is easy to rub off and redraw.

7 Cut the tiles as you go along, and build up the design area by area. This piece is not going to be grouted, so the tiles have been laid closer than they otherwise would have been. Ungrouted mosaic has a light, flickery effect and tends to look less flat than a grouted piece.

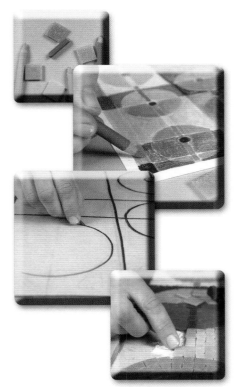

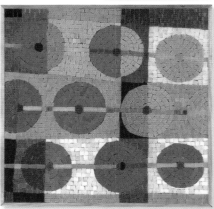

With the mosaic completed, it is interesting to see how the source of inspiration relates to the finished item.

Direct Method

The direct method is a good technique for beginners, because it is relatively quick and easy. Its biggest advantage is that what you see while you are working is very close in appearance to the finished product.

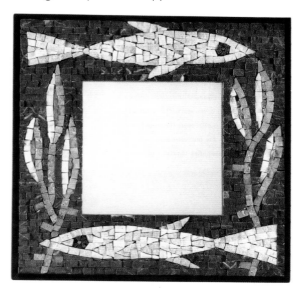

The fact that as you work you can see the "right" side of the tiles is important when you are using marble, which can differ dramatically in tone, finish, and color from one side to another. It is also important with small and intricate mosaics, which depend on precise tonal gradation. It is also particularly suitable for pieces that employ texture or relief; because the indirect method tends to flatten out these effects.

TOOLS AND MATERIALS
- ❏ Tile nippers
- ❏ Adhesive brush
- ❏ Paintbrush
- ❏ Framed board
- ❏ Charcoal
- ❏ Building silicone
- ❏ Mirror
- ❏ White craft glue
- ❏ Selections of tiles, including marble cubes and smalti
- ❏ Paint

I Cut a backing board for your mosaic mirror, and attach a frame around the edge of it. Rule lines between the opposing corners to identify the center of the board. Draw your design onto the board with charcoal, leaving the area for the mirror clear.

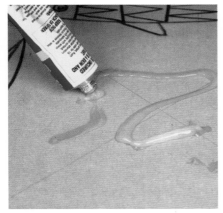

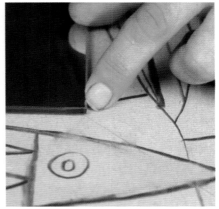

2 Spread building silicone on the center of the board. At this stage there is no need to get a smooth coat of glue over all the area the mirror will cover, just enough glue in the central area to hold the mirror once it is held upright.

3 Place the mirror, reflective side up, on the board. Move it around to spread the adhesive until it feels as if it is thoroughly and evenly coated. Use the diagonal rule lines as a guide for placement: they should meet each corner of the mirror. Press flat.

4 Cut your tiles. This mirror frame is made with riven marble cut from cubes. Place glue on the board, not on the tiles. If you apply the glue too thickly it will squeeze up between the pieces. If it is too thin, the pieces will fall off. Begin by working on the principal features.

5 The lines drawn represent changes in color of the material. As you begin work, you may find that the material has cut in an interesting or unpredictable way and you may want to amend your design accordingly. You would be unable to do this if the background were already laid.

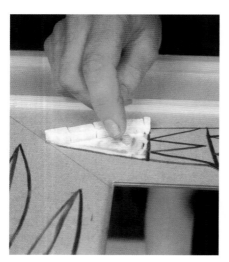

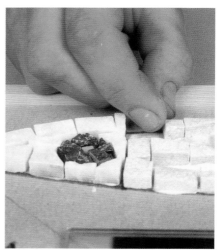

6 For each area of color, spread the craft glue within the charcoal lines using a small brush. By working on one area at a time you can keep to your design more accurately than if you were to spread adhesive over the whole board. It also allows you to work at your own pace.

7 If you have very tiny or narrow pieces to lay, it is helpful to put some adjacent larger tiles in place to support the smaller ones. Otherwise, unsupported tiles may fall over, into the glue.

8 Once the principal motifs have been laid, you can work on the background. If this is tricky to cut, like the gap between the leaves here, it may be useful to break a general rule and lay it at the same time as the foreground. If you do this before the glue has set, you can move tiles around, even opening the joints to redefine a shape slightly if you have an area that seems impossible to cut effectively.

9 Continue putting in the background, still applying the craft glue to one small area at a time. This allows you to cut small batches of tesserae as you go along, rather than cutting too few or too many.

10 In order to produce a neatly finished edge, work from the frame toward the fish motifs. When the glue is completely dry, paint the frame and when the paint is also dry screw mounts into the board so you can hang it up.

Direct Method on Mesh

Mesh is useful for small domestic projects when you wish to have an idea of the finished effect as you work. This technique eliminates the need to work in the indirect method and simplifies the fixing process.

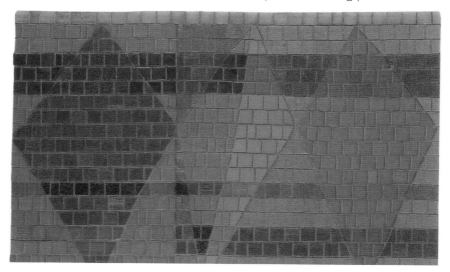

This technique also allows you to assemble the piece away from the actual location where you want to fix it. But you cannot use this technique for pieces that are to go outside, as the craft glue is not suitable for exterior use.

Above: *This panel uses selective cutting of tiles to contrast the shapes of the blocks of color with the overall strong rhythm of Opus Regulatum (see page 104).*

TOOLS AND MATERIALS

❑ Scissors
❑ Permanent marker
❑ Sticky tape
❑ Tile nippers
❑ 1/8 inch (3 mm) notched trowel
❑ Small board
❑ Hammer
❑ Grouting squeegee
❑ Sponge
❑ Lint-free cloth
❑ Mesh
❑ Plastic wrap
❑ Water-soluble white craft glue
❑ Selection of vitreous glass tiles
❑ Cement-based adhesive grout

1 Cut the mesh carefully with scissors, so that you can use its straight lines as a grid for your design. Place a layer of plastic wrap or silicone-backed paper under the mesh, to prevent the piece from sticking to the work surface. Using a permanent marker, draw your design onto the mesh. Leave a margin of mesh at the edge.

2 To hold the mesh still while you work, tape down the edges. To liven up a muted design, this mosaic has a bright border. Cut tiles along an edge may look unsightly, so start by laying the border with whole tiles. Apply the craft glue thickly to the mesh to hold the tiles firmly in position, since the mesh will flex as the mosaic is fixed in place.

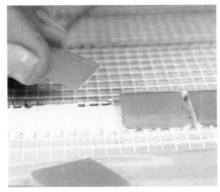

3 Build up the design area by area. Do not apply too much glue at any one time, particularly in places that require intricate, time-consuming cutting of the tiles. If the glue is allowed to dry, it will leave a lumpy base for the tiles. Once the mosaic is complete, leave it to dry.

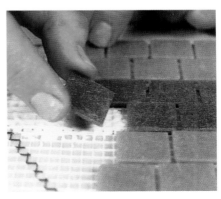

4 Once the whole mosaic is dry, remove the sticky tape and cut off the surplus mesh as closely to the tiles as you can. Remove the plastic wrap or paper from the back of the mosaic. After mixing cement-based adhesive with water to a creamy consistency, apply it evenly to the chosen surface, pressing down hard with a 1/8 inch (3 mm) notched trowel.

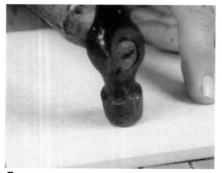

5 Place the mosaic into the adhesive, carefully aligning the corners. To guarantee the mosaic is bedded flat, take a hammer and small board and tap the entire surface. Leave to set.

6 In this case, the mid-tone of the mosaic is a slightly darker color than gray grout. A good tonal match has been achieved by mixing powders of gray and black grout. Mix powdered grout with water.

7 Apply grout to the mosaic and press into all the joints with a grouting squeegee. Clean off the grout with a moist sponge. Once the mosaic is dry, buff with a lint-free cloth.

Double Reverse Method

This method allows you to lay the mosaic out as if you were working directly, then turn it over and gain the benefits of working in reverse as in the indirect method.

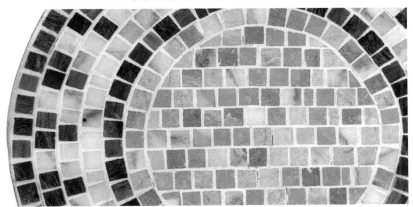

When you can't fix directly to a board or surface, but you are working with a material, such as glazed tiles or marble, which may have an entirely different appearance on one side from the other, you need a reverse method that allows you to see what the design is going to look like. This is when the double reverse method is helpful. You can use this method only if the tiles are roughly the same thickness.

TOOLS AND MATERIALS

- ❏ Jigsaw
- ❏ Compass
- ❏ Pencil
- ❏ Scissors
- ❏ Charcoal
- ❏ Paintbrush
- ❏ 2 large boards
- ❏ Sponge
- ❏ Grouting squeegee
- ❏ Spatula or small tool
- ❏ 3 mm notched trowel
- ❏ Small board
- ❏ Hammer
- ❏ Lint-free cloth
- ❏ Plywood or particleboard
- ❏ Paper
- ❏ Water-soluble white craft glue
- ❏ Selection of marble tiles
- ❏ Grout
- ❏ Cement-based adhesive
- ❏ Adhesive latex admix
- ❏ Copper strip
- ❏ Brass pins

I Cut a circular board from a sheet of plywood or particleboard to use as a tabletop. On a piece of paper, draw two identical circles with a compass. Make them both fractionally smaller than the tabletop. Cut them out and make sure they fit neatly on the tabletop. Set one of the paper circles aside.

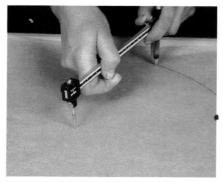

2 When you are designing a mosaic you should always take into account the size of the tiles. An arrangement of tiles in a pattern like this needs to be planned carefully to ensure that it works out exactly. It can help to draw guidelines onto the paper using charcoal.

3 When you are sure your design repeats correctly, sketch it onto the paper so you can follow it closely

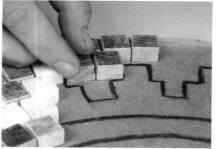

4 Using a weak mix of water-soluble white craft glue (70% water and 30% glue), stick the marble tiles to the paper. Make sure you get the spacing right, because this is how the completed mosaic will appear. Begin with the border and, when it is completed, fill in the center. Once finished, set aside to dry.

5 Place the second paper circle on a flat surface. With a large paintbrush, coat the paper thoroughly with a stronger solution of glue (40% water and 60% white craft glue). It is vital that the paper is covered completely; any gaps will cause the mosaic to fall apart. Work quickly so the paper does not have time to stretch.

6 Place the glue-coated paper on top of the mosaic. The circle should fit precisely. If it does not, realign it until you have a perfect fit. Press the paper flat on the polished face of the tiles.

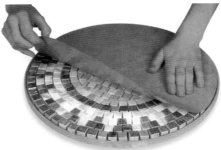

8 Wet the top paper thoroughly with a moist but not dripping wet sponge. Leave it for ten minutes, checking regularly to see if any paler patches have appeared. If so, rewet thoroughly, but do not use so much water that it soaks into the paper underneath. After ten minutes the paper should be saturated and will have turned a dark brown. Experiment with peeling back the paper. If there is some resistance, rewet. If not, peel it back, starting from one corner and peeling toward the center. Place the paper back down again (it will not restick) and peel from the opposite side. If you displace any tiles in the process of peeling, put them back into the hole they came from, checking that the joint is correctly aligned. Reglue any tiles that have come loose. Leave to dry.

7 Moving quickly, sandwich the mosaic between two boards, gripping both tightly, and turn it over. Remove the upper board. Press the mosaic hard through the paper to ensure that every piece has made contact with the glue-coated paper now on the bottom. Leave to dry

9 Pregrout the mosaic (see Grouting Techniques, pages 83-85). Clean the grout off with a sponge that has been thoroughly squeezed dry.

10 Once the grout is in the joints and the mosaic is clean, you can compensate for any slight differences in the depth of the tiles by laying a coat of cement-based adhesive up to the thickness of the thickest tile. This is known as "buttering the back." Apply with a spatula or small tool, and make sure it is level.

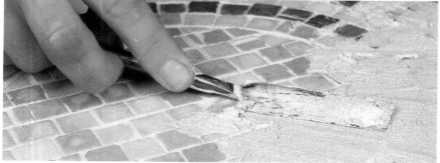

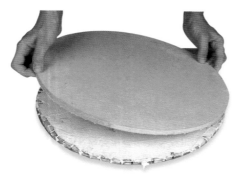

11 Mix the cement-based adhesive with a latex admix combined with water so that it bonds securely with the wood. Use a ¹/8 inch (3 mm) notched trowel to apply adhesive to the tabletop. The trowel acts as a gauge to ensure that the adhesive is applied evenly, so make sure you press hard. Put your mosaic on a large board. If the mosaic is small enough, place the tabletop on it, rather than turning the wet, heavy mosaic over. Turn over.

12 To ensure that the surface is flat and there is no air trapped between the layers of adhesive, place a small board on top of the mosaic and move it across, gently tapping it with a hammer. The aim is to make the thicker tiles butt up close to the board, displacing adhesive, which then will support the thinner ones. This creates an even, flat surface.

13 Wet the paper thoroughly; when saturated, peel it off. While the adhesive is still wet, carefully sponge any remaining glue and grout from the surface. Work from the edge to the center so you do not move any tiles. The aim is not to clean the surface, but rather to ensure that the grout is smooth. Leave to dry. Regrout from the front. Clean off with a sponge. Buff up with a lint-free cloth.

14 Once the mosaic is dry, attach a copper strip to the outside of the board to act as a frame. Use brass pins to attach the strip, because these will not rust. Finally, grout the junction between the mosaic and the frame.

77

Finishing and Fixing

The overall impression of a mosaic can be spoiled if the work is not finished to a high standard. These details make a mosaic complete and presentable. Although such finishing touches may seem minor, it is surprising how much some small details can affect the final impression of a mosaic.

It is easy to think that once a mosaic is grouted or the tiles fixed into place, that you have finished your work. After laboring away making a piece, sometimes for weeks, it seems only fair to think of it as finished when you have it stuck in position. There are, however, minor details in presentation that can make all the difference in how it looks. Finishing and fixing are not only matters of presentation; they are essential for protecting your mosaic from the elements and accidental damage. Presented here are some of the most common finishing processes that may apply to your mosaic.

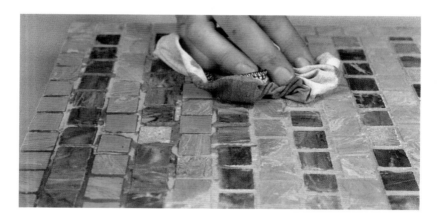

Applying sealant to a cast slab: Polished marble gains some chemical resistance to staining from the structure of its glassy surface, but honed or riven marble is more vulnerable and needs protection. To give terra-cotta and marble some protection from dirt and grime, apply sealant with a lint-free cloth. If you have made a tabletop with marble tiles, it is a good idea to use a sealant that also protects it against staining from spillages of oil and wine.

Buff up a completed mosaic with a dry cloth. It is surprising how easy it is not to clean a mosaic properly. Sometimes it is difficult to see whether or not all the grout has been removed, particularly when the tiles are dark in color. The cloth abrades any film of grout left on the surface, and leaves the mosaic shiny and clean. The only exception to this is unglazed ceramic, which must be cleaned with water during the fixing process, because it will not rub clean later on.

Paint the frames and backs of completed mosaics. It is more sensible to do this before the mosaic is fixed, although you will probably need to retouch the paint once the mosaic is in position. Give as much thought to the paint color as you gave to the color of the tiles, because it will be setting off the appearance of the completed work.

Tile trim should be carefully applied. This piece of tile trim demonstrates the way in which tesserae should fit neatly flush up to the edge, protecting what would otherwise be vulnerable tiles. The tile trim should be feathered in to the adhesive (gradually building up to the trim with adhesive) to avoid an unsightly bump in a row of tiles, created by the thickness of the trim beneath.

Pay attention to the ways in which you attach fixings to the completed mosaic. Measure carefully to ensure that they are placed at an even distance from each side of the piece. If they are unevenly placed, it will be difficult to get the piece to hang straight.

Be careful framing tabletops. The frame must not extend higher than the level of the fixed mosaic or it will catch against things you place on the table. If the frame is made for a table that you plan to use outside this is even more critical, since a lip that extends higher than the level of the tiles will act as a water trap.

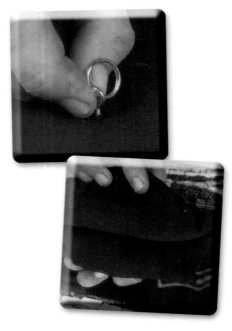

Use eyelet screws for hanging mosaics on walls. Fix two at even intervals to the back of the mosaic, then lace brass wire through the rings.

When cleaning mirrors incorporated in a mosaic, avoid spraying glass cleanser on the mosaic itself. If the grout absorbs the cleanser, it may change color slightly, giving it a blotchy appearance.

Using Glass and Silicone

Stained glass and mosaic are similar in many ways. Both materials fracture an image through a series of joints. These materials can be used together to good effect and the combination of vitreous glass mosaic tiles and stained glass gives a very striking result.

Although stained glass needs light for the full effect of the color to be appreciated, the use of opaque glass and the mosaic technique means that this lamp shade is also appealing when it is not illuminated.

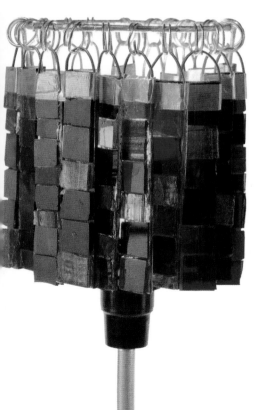

TOOLS AND MATERIALS
❑ Tools
❑ Glass cutter
❑ Tile nippers
❑ Materials
❑ Stained glass tiles
❑ Vitreous glass tiles
❑ Table lamp
❑ Lamp shade
❑ Building silicone or glass glue
❑ Copper wire
❑ Self-adhesive copper tape
❑ Copper rings

1 Choose stained glass and vitreous glass tiles that complement each other. Remove the existing paper shade from its substructure, from which you will hang your mosaic strips. After calculating the length of the glass pieces, bearing in mind that the copper wire and rings by which they are hung will increase their length, cut glass strips.

2 To make stained glass mosaic tiles, cut additional glass strips with the glass cutter. These narrow strips of glass are easy to cut into square tiles with normal tile nippers.

3 Apply clear building silicone or glass glue to the glass strips. Do not apply so much that it squeezes up between the joints.

4 Place the tiles you cut into the building silicone. This piece will not be grouted, so take care to keep surfaces clean and the spacing even.

5 The glass strips will be attached to the lamp shade with hooks made of copper wire. These are simple to make: Just bend a small piece of copper wire over the top of the strip and tape it into position with self-adhesive copper tape.

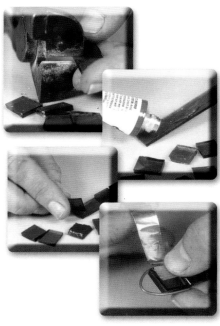

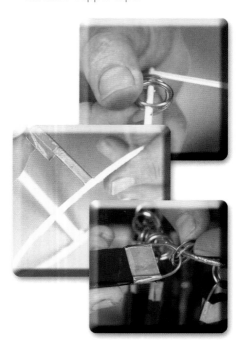

6 Thread the copper rings onto the base of the shade before you apply the copper tape, or the process of threading them may damage it.

7 Copper tape can be used to cover the shade's substructure. It is best to cut the tape into small pieces and apply each piece individually.

8 When the substructure is covered in tape and the rings are attached, hook the mosaic strips to the copper rings. Make sure you have an equal number on both sides of the shade. The glass shade is attached to the lamp as you would a normal shade.

Grouting Techniques

Grout is the matrix that goes between the tiles. It has a major influence on the finished appearance of the mosaic, so although the application of grout is the final stage of fixing a mosaic, it must not be treated as an afterthought.

TOOLS AND MATERIALS
- ❑ Container for grout
- ❑ Container for water
- ❑ Container for adhesive
- ❑ 2 wallpaper scrapers, one for mixing grout, one for adhesive
- ❑ Grouting squeegee
- ❑ Sponge
- ❑ Notched trowel
- ❑ I sheet mosaic tiles
- ❑ Grout
- ❑ Cement-based adhesive
- ❑ Board

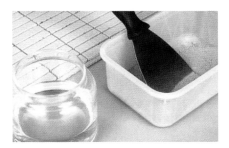

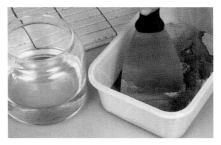

I Put the powdered grout into a container. It is important to make up a large enough batch, because once you begin, you need to work quickly. The paper will be absorbing water from the grout you have applied. and you must turn the mosaic over before the bond between tile and paper is affected by moisture.

2 Mix the grout with water to a creamy consistency. Do not make the mix too wet. Fill a second container with water, which you will use when you sponge off the excess grout. Mix up your adhesive.

3 Apply the grout to the back of the tiles with a grouting squeegee. Make sure all the joints are filled. This is most easily achieved by sweeping the squeegee horizontally and then vertically.

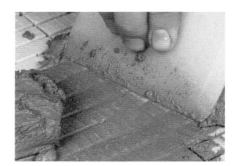

4 Wet your sponge and squeeze it out as much as possible. Clean off the excess grout by pressing one side of the sponge flat to the mosaic. Turn the sponge over and repeat. It is essential to use a clean area of sponge each time; otherwise you will simply reapply all the grout you previously removed. Once clean, set aside.

5 Apply adhesive to the board, using a notched trowel.

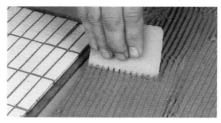

6 Pick up your sheet of mosaic and turn it over. The easiest way to do this is by holding either two corners or two opposing edges of the paper and pulling outward slightly as you might pull a sheet. Do not put one hand underneath and the other on top because the paper might flop or fold, causing tiles to fall off. Place the mosaic into the adhesive with the backing paper face up. Make sure you align it correctly, with nothing overhanging the board.

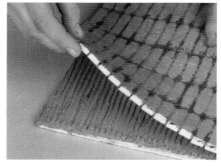

7 Wipe the paper with a damp sponge. Do not make it so wet that water runs into the adhesive.

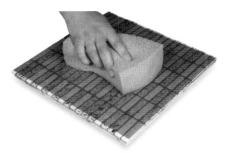

8 When the paper is really dark in color (it generally takes about ten minutes), peel it off. Start from one corner and peel toward the center. Place the paper back down again (it will not restick) and peel from the opposite side. If you displace any tiles in the process of peeling, put them back into the hole they came from, checking that the joint is correctly aligned. Once again, clean the mosaic with a sponge that has been thoroughly squeezed out. This will ensure that the grout is smooth and free from lumps. Leave to dry.

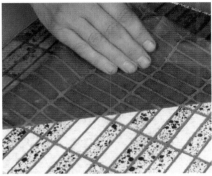

9 Regrout from the front. Because the mosaic has set, you can be more vigorous.

10 Sponge the grout off the face of the mosaic, as before. When it has dried, buff up with a lint-free cloth.

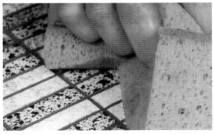

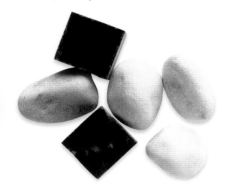

Indirect Method on Paper

The indirect method is sometimes also known as the reverse method, because the image has to be reversed; it is the method most commonly used by professional mosaicists. The advantage of this method is that the mosaic can be made away from the place in which it is finally fixed.

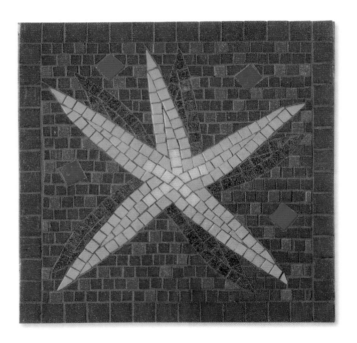

TOOLS AND MATERIALS

- ❑ Scissors
- ❑ Board
- ❑ Adhesive brush
- ❑ Tile nippers
- ❑ Grouting squeegee
- ❑ Sponge
- ❑ ¹/₈ inch (3 mm) notched trowel
- ❑ Brown paper
- ❑ Permanent marker
- ❑ Water-soluble white craft glue
- ❑ Tiles, here vitreous glass mosaic tiles
- ❑ Grout
- ❑ Cement-based adhesive

1 Cut a piece of brown paper slightly smaller than the size of the board to which you plan to fix the mosaic. Draw out your design onto the matte side of the paper. Remember that any drawing you do will be reversed in the final mosaic, so numbers and letters need to be drawn in reverse at this stage.

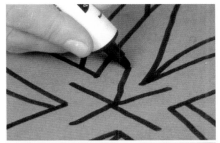

2 Stick the mosaic to the paper using a water-soluble white craft glue diluted 50:50 with water. Start the piece by laying the border with whole tiles, using the adhesive brush to apply glue to the paper as you work. When the border is in place, lay the main motif, and fill in the background last.

3 The glue needs to dry out thoroughly when you have all the tiles in place. Once dry, pregrout the mosaic, pushing the grout into the joints with a grouting squeegee.

4 Use a damp sponge to remove excess grout from the back of the tiles. Grout must not be left on the back of the mosaic because it will prevent proper bonding with the adhesive on the board.

5 Mix up cement-based adhesive and use a $1/8$ inch (3 mm) notched trowel to apply a layer to the board. Make sure the teeth of the trowel touch the board, to ensure that an even thickness of adhesive is laid across the whole area.

6 Place the pregrouted mosaic into the adhesive, paper side up. Be sure to align the corners properly before putting the paper in place.

7 Wet the paper with a thoroughly wet sponge. Leave the paper to absorb moisture for at least five to ten minutes.

8 Peel off the paper, starting from one corner and working toward the center. The tiles along the edge of the mosaic are always the most vulnerable to movement. If any come away, place them back in position ensuring that there is adequate adhesive behind them. Once you have peeled into the center of the mosaic, replace the paper (it will not restick) and start to peel from the opposing corner. Once the paper has been peeled off, clean the mosaic immediately with a thoroughly squeezed out sponge. Leave to dry.

9 Once the mosaic is dry, regrout from the front, making sure that all the tiny holes are filled.

10 Wet a clean sponge and squeeze out as much water as possible. Use this to clean the grout off the mosaic and buff up with a soft cloth.

Indirect Method on Plastic

You cannot use the indirect method on glazed tiles, because it is impossible to plan a design in terms of color and pattern without seeing what you are creating. However, with small projects, such as this tile-sized piece, you can use a variant of the indirect method by arranging the design the right way up and sticking plastic to the face.

This method is not to be used for large pieces, as there is too much risk of the tiles moving around as you lay on the adhesive-backed plastic. It is important to keep your working surface clean as dust may interfere with adhesion of the plastic to the tiles. An advantage to this method is that even if you use tiles of different thicknesses the finished piece will have a flat surface.

TOOLS AND MATERIALS
❑ Scissors
❑ Tile nippers
❑ Notched trowel
❑ Hammer
❑ Rubber gloves
❑ Grouting squeegee
❑ Sponge
❑ Lint-free cloth
❑ 2 boards
❑ Adhesive-backed plastic
❑ Glazed ceramic tiles
❑ Cement-based adhesive
❑ Latex admix
❑ Grout

1 Draw your design on a board or sheet of paper. Decide on the colors you wish to use. Cut a piece of adhesive-backed plastic to the size of your design and set aside.

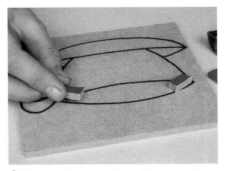

2 Dry lay (lay the tiles without glue) on the board or paper.

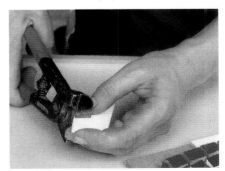

3 Once the design is complete, peel the adhesive-backed plastic from its backing and lay it on the face of the tiles. Be careful not to disturb the tiles, because once they have adhered to the plastic, you cannot change their positions.

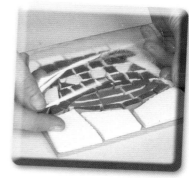

4 Use another board to sandwich the mosaic and turn it over.

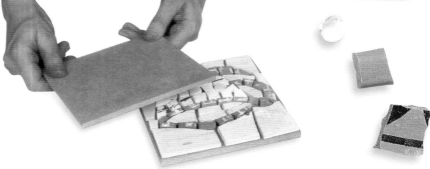

5 Mix up the cement-based adhesive. This adhesive requires a latex admix combined with water to bond securely to wood. This is usually mixed in a 50:50 ratio, but check the manufacturer's instructions. Using the notches on the trowel to make sure you spread an even quantity across the whole area, trowel the mixture onto the surface on which the mosaic is going to be placed. The mosaic is not pregrouted in this method.
Lay the tile-sized mosaic into the adhesive, aligning the corners carefully.

6 With a small board and hammer, beat the mosaic flat to ensure that even the smallest piece has made contact with the adhesive.

7 Because you have not pregrouted, there is no need to peel the plastic off immediately. Give the adhesive time to dry before attempting to peel away the plastic.

8 Mix powdered grout and water to a fairly stiff consistency. If the grout is firm, it is less likely that you will have to grout again; with a wet mix, water evaporates from the joints, causing them to sink. You can grout a small item like this with your hands, rather than using a squeegee, as long as you wear rubber gloves. Sponge clean, then leave to dry. Buff with a lint-free cloth.

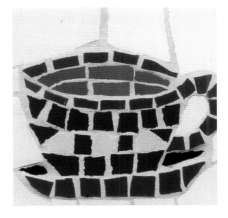

This technique is ideal for small panels such as this one, which is themed for an area of tiling in a kitchen.

Laying Tesserae

The way in which tiles are laid expresses a mood or gives a sense of animation or calm to a mosaic. This section looks at some of the ways in which they can be laid.

When we talk about laying mosaic, what we are really discussing are different ways of arranging the space between mosaic tiles. It doesn't really matter how far apart you space the tiles from one another, but whatever you decide the gap is going to be, you must maintain it for the whole of your mosaic. There may be a creative way of spacing the tiles so that there is a contrasting gap size in different areas or motifs, but as a general rule, a mosaic will look much more harmonious if the spacing is even.

QUARTER TILES

Most mosaicists work with quarter tiles as a balance between using tesserae that are small enough to make detailed designs, but not having to make too many cuts.

1 This way of arranging tiles is known as Opus Regulatum. It is mosaic which is laid straight in two directions. It is the way mosaic tiles are laid when supplied from the factory.

2 This is also known as Opus Regulatum or Opus Tessalatum. The rows are offset, and it is important to try and maintain the keying effect, since the eye is quick to notice areas of geometrical regularity

3 This is Opus Regulatum that has been laid to express movement. In order to allow the tiles to flow around curves they have been slightly angled along one side. It always looks best if the angles are kept flowing in the same direction.

This diagram demonstrates an undesirable way to lay mosaic. One angle has been cut to help the tiles move around a curve, but another angled piece has been cut as an answering shape. If you find yourself cutting angles on a tile opposite to the ones you cut on the previous tile, you need not have cut the first angle.

This diagram shows how the tiles should be laid to make the most flowing curves. The angles of the cuts express the direction in which the curve is traveling. Each tile is cut evenly on both sides, so it tapers toward the base. Compare this to the next diagram where the tiles are cut in both directions.

This shows the effect of cuts that do not echo the direction of the curve. It is distracting to the eye and interferes with the rhythm of the curves.

To make tiles radiate out from a central point you will have to cut tiles on both sides.

Once you have produced a slightly odd cut, the next tiles are forced into increasingly odd angles by it. Discard any oddly cut tiles and start again.

If you are working in this radiating way and are finding it hard to make angled cuts which express the way the tiles move round the circle, you may find it helpful to divide up the space geometrically with a ruler. Geometrical precision is not necessary, but if you place the tile you plan to cut over the marks you have made on the paper, they remind you which side of the tile you have to cut.

You can create emphasis by laying sections of mosaic in opposing directions.

This is an example of Opus Circumactum. Where the tops of the circles meet and the area of infill begins it is important that you cut the tiles equally on all sides so no circle is given precedence over another.

This fan design is a traditional mosaic background. To make it work effectively it is important to observe the previous remarks about cutting sympathetically to the flow of each curve.

HALF TILES

You can employ many of the same laying methods just as creatively by using half tiles instead of quarter tiles.

This is a random mix of half, quarter, and whole tiles. This sort of treatment was very popular in the 1950s, when contrast was of great interest to mosaicists.

This is herringbone pattern, also known as Opus Spicatum. It creates quite a busy effect, and can be rather tricky to arrange around images.

This basketweave effect has an attractive rhythm and is quick to produce.

This is a version of Opus Tessalatum for half tiles.

The rules that apply to producing this design effectively in quarter tiles also apply here. Using half tiles does increase the speed at which you can work, and this pattern is quick to produce.

This is a version of Opus Tessalatum moving around a curve. You could use half and quarter tiles in the same piece.

Opus Regulatum with half tiles is saved from dullness by the variation in the cut edges.

Contrasting the directions in which tiles are laid creates strong lines in a background.

You can break a repeating system by suddenly laying the tiles in a different direction. This background treatment is worth considering to give emphasis in particular parts of your mosaic.

TILES CUT TO SPECIAL SHAPES

Part of the enjoyment of making mosaic involves cutting the tiles. At first this can seem rather off-putting, but gradually you gain control of the tile nippers and they become as versatile as scissors, allowing you to cut ambitious and interesting shapes of tiles.

Circles can be laid to set up their own patterns. A certain degree of wobbliness in the shape only adds to the charm.

Randomly curved shapes were once very popular, and they do give a lovely organic, rather scaley impression.

To vary the effect of organic shapes, and to speed up the process, you can include some quarter tiles. It can be useful to combine different shapes, as you are often left with some strange-shaped spaces when cutting and laying these tiles.

This version of Opus Palladianum gives a lively, fractured effect.

These honeycomb shapes are rather arduous to cut, but give a wonderful pattern.

Long two-angled cuts like these are useful as patterns in themselves, but they also help create a feathery impression.

A SINGLE SHAPE DESCRIBED IN A SERIES OF WAYS

This leaf shape has been made up in six different ways in order to drive home the point that the ways in which you can construct a single form are almost infinite. There is also no single right way to do it. Different ways of cutting and laying create a variety of impressions, and it is up to you to decide what is appropriate for the mosaic you are producing.

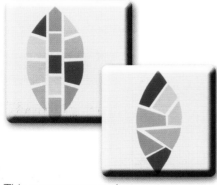

This arrangement makes a more obvious reference to a central stem.

Providing you are disciplined about laying tiles precisely to the outside of the shape, this can be a quick way of forming a leaf.

This suggests the symmetry and skeleton of a leaf. It is a pleasing effect, but would be difficult to achieve if the leaf were large, as it requires long cuts from a whole tile.

The leaf here has been conventionally treated. Note that the bottom is laid slightly differently from the top. The single tile at the top is a very satisfactory leaftip, but the two cut tiles at the bottom do help to suggest a stem.

This way of laying a leaf might be useful if you wanted to suggest movement.

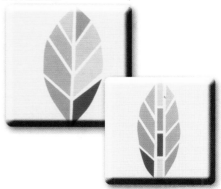

This approach refers to a central stalk and also divides the shape skeletally.

97

Micromosaic

It is impossible to pretend that micromosaic is anything other than time-consuming and tricky. You have to be prepared for hours of patient labor, and because the image grows at a snail's pace, you do not get immediate gratification. However, micromosaic has a unique effect.

This project was taken on as a technical challenge and represents months of work. If you want to try working with micromosaic, it would be best to start with something really small. If you work with normal size tiles, you can experiment with fine transitions of color only if the whole piece is very large. If it is not possible to work large, the only other way you can experiment like that is to work with really small pieces. It also increases the scope of your mosaic palette, particularly in relation to tone. You can use the natural tonal variations within a piece of marble to create sophisticated effects.

TOOLS AND MATERIALS
❑ Scissors
❑ Board
❑ Adhesive brush
❑ Tile nippers
❑ Grouting squeegee
❑ Sponge
❑ ¹/₈ inch (3 mm) notched trowel
❑ Tweezers and a pin
❑ Brown paper
❑ Gummed paper tape
❑ Water-soluble white craft glue
❑ Selection of marble rods

▌This micromosaic is a reproduction of the theater scene from the House of the Tragic Poet in Pompeii, Italy, an ancient Roman town that was buried by a volcanic eruption in 79 A.D. Reproducing in accurate detail the lines of coursing of the original and the tonal and color variations represents a real challenge.

2 Because the piece aims to reproduce the original as accurately as possible, a sketch has been made exactly the same size as the original, delineating the principal features. The piece is being made by the indirect method, so the drawing must be reversed.

3 When working with such tiny pieces, the slightest degree of paper stretching presents problems. If the paper expands at all as the glue is applied, it can dislodge the tiny tesserae, creating gaps. In order to prevent this, the paper needs to be stretched before any tiles are stuck to it. Immerse the paper in water and stick it to the board with brown paper tape. Once the paper has dried, the design can be drawn onto it.

4 Here you can see the range of marble colors chosen to stand in for those used in the original. When working at such a scale, the tonal variation within a single cube can represent a considerable color change.

5 Thin rods of marble are cut and the individual tesserae are cut down from them. Enormous care needs to be taken in cutting these individual pieces since any swelling of the tiny cubes at the base or at the top means that adjoining tiles will not fit neatly against each other, leaving unsightly gaps. The tiny cubes, therefore, need to be cut absolutely straight.

6 The only way to work with such minute pieces is with a pair of tweezers and a pin. Spread glue over a very small area of paper at a time. Lay the defining outer lines first, leave them to dry, and then work up against them. Otherwise, it is easy to keep knocking the cubes out of position.

7 Some of the pieces in these faces are smaller than the head of a pin. The mosaic will probably need some reworking in the fixing process, because facial expressions are apt to change enormously with even tiny displacements in the position of a tile. Once the mosaic is complete, pregrout it, build up any differences in levels by buttering the back, and fix in place.

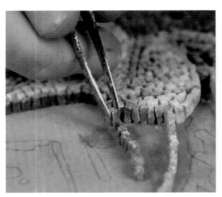

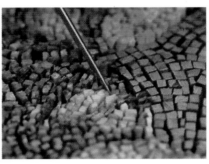

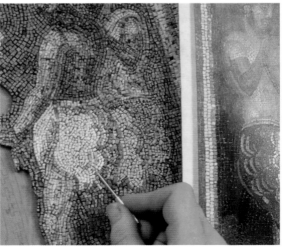

You can see that the way the tiles are laid gives a variety of rhythmic effects to the finished piece. The way the sheepskin around the men's waists is laid will give an impression of the animal's shaggy coat. The way the musculature in the legs is laid helps describe the form. The principles behind working at this scale are the same as working a larger scale, just trickier to achieve.

100

Opus

The term Opus means "work" in Latin. The second part of each Opus name describes the style of laying, also based on Latin terminology. These terms are shorthand ways of describing the system by which the tiles in any mosaic are laid relative to one another.

The ways in which mosaic tesserae are laid out or constructed are called the Opus (opera is the plural). A mosaic can be constructed using one or more of the methods and to a greater or lesser extent. There is a wide diversity and latitude in the laying of the material. Each mosaicist develops a personal style. By understanding the opus techniques, however. a deeper understanding of the placing of the materials is reached.

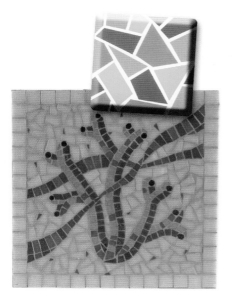

OPUS PALLADIANUM

This kind of background treatment is lively and effective. It is also quick and easy to produce. It is an ideal way of working for a beginner, or someone who is still perfecting his or her cutting skills. You will produce a harmonious and balanced-looking background by leaving an even gap between tiles. The gap can be small or large, since in either case the size of the gap is less important than the fact that it is even throughout.

OPUS CIRCUMACTUM

This technique is related to the traditional mosaic fan shape. It is useful for square mosaics, where the tiles are laid in quarter circles from the edge, and meet neatly in the center. The effect is rhythmic and pleasing.
It isn't always easy to select a background treatment for a mosaic, particularly a small one. Opus Regulatum can give a very static effect. Opus Vermiculatum can be rather frantic and chaotic. Opus Palladianum is very pleasing, but it is rather busy. Sometimes you need a background treatment that is interesting and gives a sense of movement, without being overbearing. Opus Circumactum is probably the best solution in this case.

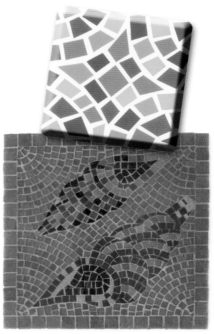

ANDAMENTO

This is the way in which the tesserae are made to flow in directional lines. By being aware of the flow of the material, areas of rhythm and tension can be built up, contrasted, or exaggerated. The grouting lines can emphasize the flow by being of various widths and colors.

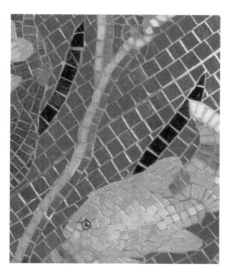

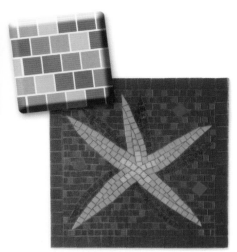

OPUS TESSELLATUM

Used frequently in Roman times. The image is surrounded by one or two bands of tesserae to define its form. The background is constructed of more or less square tesserae in a fairly uniform horizontal or vertical linear pattern. Use of this method helps to stabilize an image within its surroundings.

OPUS VERMICULATUM

Opus Vermiculatum describes the wormlike way mosaic tiles can flow around a form, creating a lively and interesting background. The tiles follow the contours of an image until they meet one another. The meeting point can be made in a sophisticated, seamlessly elegant way, or it can be a ragged, haphazard series of junctions. Both approaches have a certain appeal, and which one you choose probably depends on what the mosaic is for. When people describe classical mosaics as having a sense of movement, this is very often the technique to which they are referring. Used on a large scale it can have a wonderful effect. You can use it to give a hierarchy to images by surrounding the most significant motifs with the widest following lines.

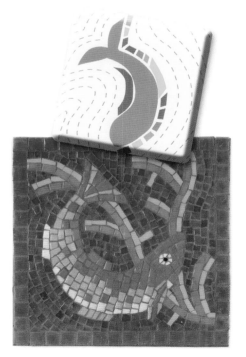

103

Opus Regulatum

This term refers to mosaic that has been straight-laid in one or two directions. An example of Opus Regulatum is sheeted-up mosaic tiles bought from the factory, which are straight-laid in both directions. It is possible to offset the rows so that they line up in only one direction, creating a sense of movement, and this kind of mosaic is also known as Opus Regulatum, or sometimes as Opus Tessalatum.

The appeal of mosaic laid in this way is that it is calming as a background. If the main features of your mosaic are lively and frantic, or the colors particularly bright, this background might be a good choice as a contrast. It is also useful to be able to make decorative features that fit into the sheeted-up material from the factory.

Opus Musivum

This occurs on larger floors when the smaller refined images of the emblemata are freed from their central position to become part of a large integrated floor creating an overall design made in an architectural setting.

Outdoor Direct Method

Working with found materials, such as broken tiles, is a creative challenge. Although they are not all the same thickness, it is possible to build up the back of the tiles with cement-based adhesive, thus producing a flat, practical surface.

A certain roughness is part of the appeal of broken-tile designs, which benefit from a free approach. The use of jagged tiles contributes to their distinctive charm. Although there is a general rule in mosaic making about not beginning with the background, in this case if the background contains the thickest tiles, that is where you

TOOLS AND MATERIALS
❏ Tile nippers
❏ Spatula or small tool
❏ Hammer
❏ Small board
❏ Knife for removing excess adhesive
❏ Grouting squeegee
❏ Lint-free cloth
❏ Board cut from marine ply
❏ Primer
❏ Charcoal
❏ Slow-setting cement-based exterior adhesive
❏ Latex admix
❏ Selection of tiles
❏ Copper strip
❏ Brass pins
❏ Black grout

must begin. Place a thin layer of adhesive under the thickest tile and a thicker layer under the thinner ones, but do not apply so much that the adhesive squeezes up between the joints. This project is a table intended for use outside. Make sure your adhesive is appropriate for exterior use.

I The base must be cut from marine ply, since other kinds of wood may not stand up to the elements. Prime the board. When the primer is dry, draw your design onto the board. Mix up some slow-setting cement-based adhesive. Some adhesives may require a latex admix to bond securely with wood. It is essential that the adhesive is slow setting, because it will take time to lay all the tiles.

2 Begin by laying the area of your design that uses the thickest tiles. All the tiles need to be laid to the depth of the thickest tile in order to be perfectly flat, and by starting with the thickest tiles, you will establish a target height for all the other tiles. Apply adhesive with a spatula or small tool.

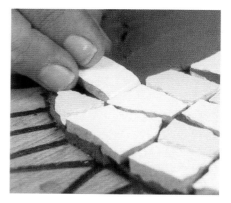

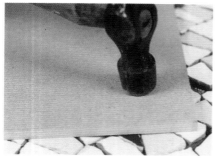

3 It is important to keep checking that the mosaic has been laid flat before the adhesive has set. To do this, you use a light hammer and a small board, gently tapping the area you have laid to ensure that the surface is level. If the adhesive has already set, you risk breaking the bond. If adhesive squeezes up between the joints as you tap, scrape it away with a knife. If you find that some tiles are low, take them out and build up the level with more adhesive.

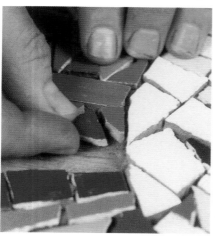

4 Once the thickest tiles have been laid, you can begin work on other areas. Again, the order of your work depends on the thickness of the tiles. In this design, the incorporation of a small number of brightly colored tiles enhances the liveliness of the gray and blue tiles.

5 When the mosaic is finished and the adhesive has set, pin a copper strip around the edge to protect it and to disguise the raw edges of the tiles. To prevent rust, use solid brass pins.

6 After the strip has been attached, grout the mosaic (see Grouting techniques, pages 83-85). A piece like this made by the direct method will need to be grouted only once. Clean the grout off with a sponge. Leave the tabletop to dry.

7 Once it has dried completely, buff the mosaic with a lint-free cloth. You can now attach it to your table base, using screws that will not rust.

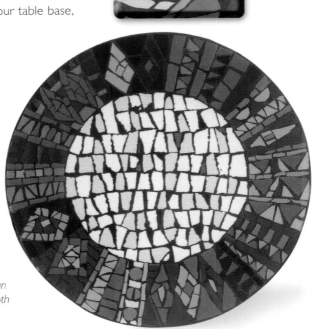

With this technique, you can make a tabletop that is both beautiful and durable.

Outdoor Indirect Method

The indirect method is ideal for pieces that you plan to use outside. Using this technique, you can create your mosaic inside, without worrying about weather conditions. You can wait for a fine day to fix the mosaic.

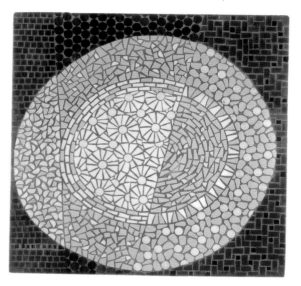

Make sure that the materials you are using are durable enough to be used externally. This applies not simply to the mosaic tiles, but also to the cement-based adhesive.

Not all adhesives are frost-proof. Check the manufacturer's instructions to ensure that the adhesive you plan to use is suitable for the task.

TOOLS AND MATERIALS
- ❑ Scissors
- ❑ Tile nippers
- ❑ Adhesive brush
- ❑ Grouting squeegee
- ❑ 1/8 inch (3 mm) notched trowel
- ❑ Sponge
- ❑ Board or surface to fix to
- ❑ Brown paper
- ❑ Charcoal
- ❑ Water-soluble white craft glue
- ❑ Mosaic tiles, including unglazed ceramic and vitreous glass
- ❑ Grout
- ❑ Cement-based adhesive
- ❑ Latex admix

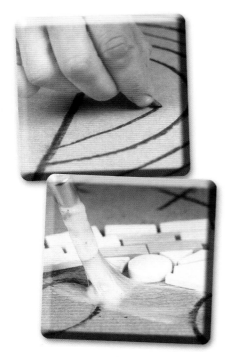

1 Cut a piece of brown paper fractionally smaller than the ultimate size of your piece, and draw your design onto it. Prepare a 50:50 solution of craft glue and water.

2 Use the brush to apply craft glue to small areas of the paper, not to the tiles. Begin fixing tiles to the most significant areas of the design.

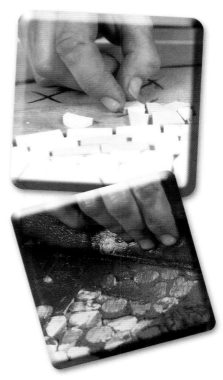

3 This design is based on cutting effects and makes creative use of the way the material fractures as it breaks. Once all the tiles have been applied, leave to dry.

4 Pregrout the mosaic (see Grouting Techniques, pages 83-85), making sure that all the gaps between the tiles have been filled.

109

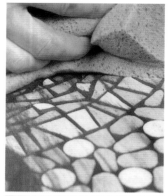

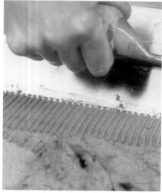

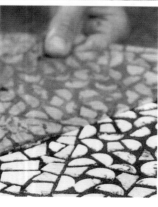

5 Wipe off excess grout with a moist sponge, using a single, flat, sweeping motion. Use a clean area of the sponge each time, or you are likely to reapply as much grout as you remove.

6 Trowel the adhesive onto the surface to which you wish to fix the mosaic, using the notches in the trowel as a gauge to achieve uniform depth. If the surface is vertical, the adhesive should be mixed thickly. Without folding it, pick up your mosaic, and place it into the adhesive. Press the surface firmly to ensure that it has made contact across all of the fixing bed.

7 After wetting the paper with a moist sponge, leave it for five to ten minutes to absorb the moisture, rewetting if it seems to be drying out. When it has turned dark brown, peel from one corner toward the middle. If tiles start to come away, particularly at the vulnerable edges, you need to wet the paper again. If one or two tiles remain stuck to the paper, place them back by hand. Once the paper has been removed, sponge the grout smooth with a moist sponge, and leave to dry. Regrout and clean once it is dry to complete the mosaic.

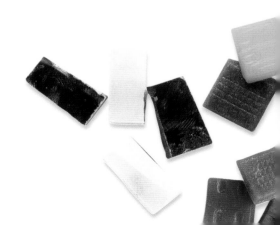

Outdoor Sand and Cement

If you want to lay a flat exterior mosaic, but need to make it from materials that have a variety of thicknesses, you cannot use cement-based adhesive. The sand and cement method can greatly extend the range of what you can do outside.

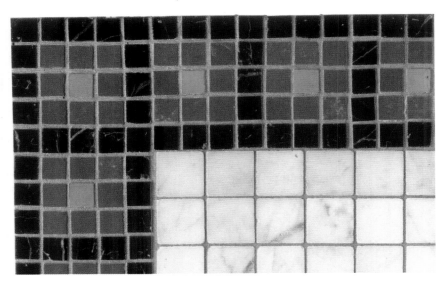

By laying your tiles into a bed of sand and cement and then tapping a board over them before the cement sets, you can level out the surface and also ensure that all the tiles are securely held in place. This technique cannot be used in all locations, as the cement screed is thick and heavy. This is not a problem outside, which is where this method is extremely useful.

TOOLS AND MATERIALS
- ❏ Carpenter's level
- ❏ Rubber gloves
- ❏ Trowel
- ❏ Flat bed or grouting squeegee
- ❏ Hammer
- ❏ Board
- ❏ Sponge
- ❏ Sand
- ❏ Cement
- ❏ Sheeted-up marble mosaic on paper
- ❏ Grout
- ❏ Stone sealant

I To lay a sand and cement screed as a fixing bed, mix four parts sharp, washed sand to one part cement, then add water until you have a workable mixture. Lay the sand-cement mix in place, checking regularly with a carpenter's level to ensure a level surface. Depending on the position of the mosaic, you may need to lay some of your screed as a gentle slope to ensure that surface water runs off the mosaic. Once complete, leave the screed to dry (or cure) for at least a week.

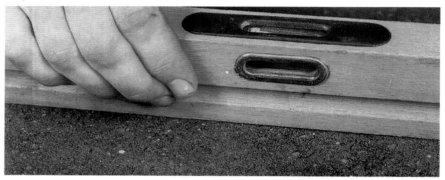

2 A cement slurry, a mixture of cement and water made to a creamy consistency, is used to fix the mosaic. Wet the cement screed and apply the slurry with a trowel, laying a thin but even quantity over the entire surface.

3 Pregrout the mosaic with cement slurry. Place it in position, then tap it all over using a board and a light hammer to ensure that the mosaic is in contact with the slurry, and that slight differences in thickness of the tiles are evened out by the bed below.

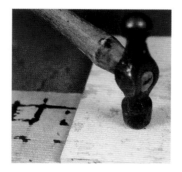

4 Wet the paper of the mosaic and leave to absorb the moisture for about ten minutes before peeling the paper off, drawing the paper gently back in a straight line. Wipe carefully with a moist sponge.

5 Once the mosaic is dry, regrout from the front.

6 Clean off thoroughly with a moist sponge. To give the mosaic resistance to staining, you can apply a special stone sealant.

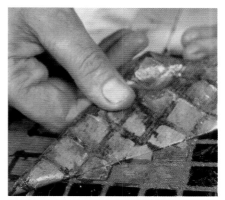

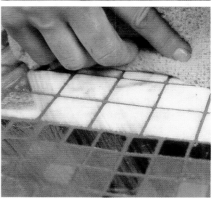

Using Pebbles

Using pebbles instead of flat ceramic or glass tiles can give an interesting textural effect. The uneven surface that this method produces is not suitable for all locations, but it does work very well in the garden. These pebble slabs are good used as outdoor paving.

It is important to be sure that the materials you plan to use can withstand the weather conditions outside. You can mix different materials, but do not try to use domestic wall tiles, or any other materials that are not intended for exterior use, or the careful labor you put into making the mosaic will be wasted. Always wear gloves when you work with cement, because it is very alkaline and can be bad for the skin.

TOOLS AND MATERIALS

- ❏ Screwdriver
- ❏ Rubber gloves
- ❏ Wallpaper scraper
- ❏ Flat-bed trowel or squeegee
- ❏ Plastic sheeting
- ❏ Small decorator's brush
- ❏ Spatula or small tool
- ❏ Board
- ❏ Hammer
- ❏ Sponge
- ❏ Casting frame (4 pieces of batten, 8 screws, backing board)
- ❏ Petroleum jelly
- ❏ Cement
- ❏ Sand
- ❏ Expanded metal lath (EML) or chicken wire
- ❏ Selection of pebbles, tiles, terra-cotta tiles, and marble cubes

1 Spread petroleum jelly all over the inside of the casting frame. Do not leave any gaps.

2 Mix together one part cement and three parts sand. Add water until it is firm and workable. Use the scraper to spread this in the frame to a depth of about one-third of your finished slab.

3 Insert a sheet of expanded metal lath (EML) or chicken wire, slightly smaller than the size of the frame. This will give the slab strength. Cover the EML with the same amount of the sand and cement mix. Press flat with a flat-bed trowel, or as here, a squeegee. Cover the wet slab with a sheet of plastic and leave to dry for a few days.

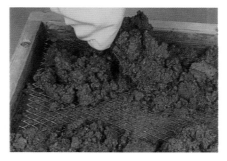

4 Once the sand and cement has had time to cure, you can apply tiles directly to it with a cement slurry. To make this, add cement to water until it has a thick creamy consistency. Remember to wear your gloves for these steps. Wet the slab, and spread the slurry onto it with the decorator's brush. With a small project, you can cover the whole area, but with larger projects you would only cover as much as you can manage quickly, perhaps one design element at a time.

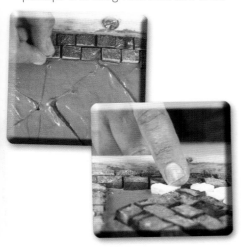

5 Working quickly but carefully, inscribe the design into the slab with a spatula or small tool. Press the tiles firmly into the fixing bed. Here the design is simple, so it is advantageous to start with the border. If you worked from the center out, you might find at the end that you need to place small cut pieces on the vulnerable edge of the slab.

6 Once the border is in place, lay the central areas. The wide gaps caused by the irregularly shaped pebbles are a feature you can use to your advantage.

7 The finished surface may be uneven as tiles displace the cement slurry. You can solve this problem with a board and a hammer. Move the board across the mosaic, hammering gently as you go and continuing until you achieve an even surface. Take care removing the board; by beating the wet slurry up through the joints, you will have created enormous suction between the board and the mosaic. Unless you break this pressure gently, by sliding the board off sideways, you'll lift tiles as you remove it.

8 Sponge the excess cement from the face of the mosaic, cover in plastic, and leave to set for a couple of weeks. Once it is dry, remove the plastic, unscrew the frame, clean, and lay in position.

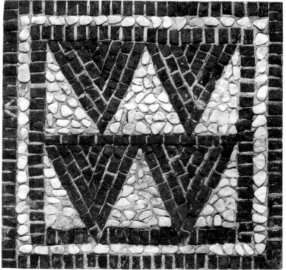

Texture is the main feature of this small panel, as the white pebbles and their shadows stand out against the smoother black surface of the marble tiles.

Fan Patterns

You can work with repeating patterns in a structured or unstructured way, making them tesselate (fit together exactly) with one another, or you can repeat a pattern and use it as a decorative motif.

Making a pattern tesselate is complex. The fundamental principle behind successful repeat patterns is to minimize cutting and maximize planning, as is done here with this small tabletop. It is assembled using the indirect method and adorned with an interlocking fan design. This is a relatively easy pattern to make tesselate, as it does not require too much complex cutting. Patterns that involve a series of diagonals, although they may look simple at first glance, are actually much trickier to produce in mosaic.

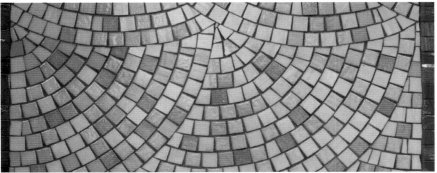

This design uses a random mix of colors, but you could emphasize the shapes by using gradated tones within each fan.

TOOLS AND MATERIALS
- ❏ Tools as for indirect method
- ❏ Brown paper
- ❏ Pair of compasses
- ❏ Pencil
- ❏ Permanent marker pen
- ❏ Water-soluble white craft glue
- ❏ Selection of tiles

I This design is based on a series of tesselating fans. Fans are a geometric derivative of circles, created from the way they interlace. Draw a circle. Put the point of the compass on any point on the edge of the newly drawn circle and draw another. Where these two circles cross, place the point of the compass and draw another one. Continue until there are many interrelated shapes across the whole sheet of paper. If you look closely at

the pattern you have just made, you will notice that the paper is covered with fan shapes. Select the orientation of the fans that you are going to use. There are three obvious orientations— the fans could all be laid pointing to the right; they could all be laid pointing to the left; or they could alternate. This design takes the alternating option. Mark your choice on your sketch.

2 Decide how many repeats you want, based on the area you wish to cover and the size of the tile module. It is useful to produce a scaled-down drawing of your work at this point. Divide the design into four sections and draw guidelines from the top to the bottom. These guidelines give you a chance to check if the points of the fans line up accurately. It is surprisingly easy for little inaccuracies to occur, and small inaccuracies become much larger over a substantial area. Start from the bottom corner of the design.

3 This tabletop needs a border to give the design a sense of being contained. Sketch in a repeating border (see Borders for guidance, pages 48-50). Color your drawing.

4 Cut out a piece of brown paper to the size of the tabletop. Sketch in the guidelines you drew on your drawing. You can either draw every fan with a series of repeating circles using a compass, as in step 1, or, perhaps more neatly, you can create one fan to the size you require and make a template. You can then draw around this to create the entire design. The points of the fans should coincide with the guidelines.

5 The border is planned, taking into consideration the height and width of the tile module. A border that ended with a cut tile along one edge would look haphazard.

6 Once the drawing is complete, you can cut your large piece of paper into smaller sections that are easier to work with. In this design the lines of division are based on the fan shapes. Once the paper is cut into pieces, you can begin sticking the tiles down.

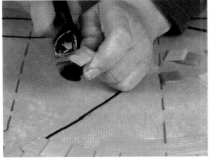

7 Although this design does not require a great deal of cutting, there are areas where the cutting is critical, especially along the edges of the fans. Cut the angled tiles first, then lay tiles into the center. You may have to trim central tiles to ensure an even fit. However, once the design is complete, you will not notice cut tiles in the center. If it is necessary to trim tiles for several lines in succession, make sure that the edges of cut tiles do not line up with one another.

Templates

The word "template" has two meanings. Sometimes it means a ready-made pattern that can be useful for beginners who have not yet developed the confidence to create their own designs. In mosaics, the word has a special meaning. It refers to a paper, or sometimes board form that represents the perimeter of an area you wish to cover in mosaic.

For example, if you wanted to make a mosaic for your bathroom, you would make a template of your bathroom floor, cutting around the sink stand, and cutting out the area occupied by the bathtub or shower. Ultimately the template represents the size and shape of the work you have to produce to cover your bathroom floor in the most accurate way possible.

TOOLS AND MATERIALS
- ❑ Ruler or yardstick
- ❑ Pencil or pen
- ❑ Permanent marker pen
- ❑ Charcoal
- ❑ Crayons
- ❑ Layout paper
- ❑ Brown paper
- ❑ Tracing paper

I In the early stage, when you are first producing your design, you must have a good idea of the size of the area you wish to cover. Begin by producing a drawing to scale, basing your design on the colors you plan to use. It is helpful to draw the size of a single mosaic tile onto your scale drawing, to check that you are planning something realistic. Sometimes it is easy to allow your imagination to run wild, without taking into consideration how you will actually create the design you have planned.

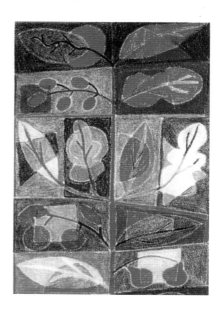

2 Once you have produced a design, draw it onto tracing paper, so you can reverse it later. Make sure you have included all the main features of your design.

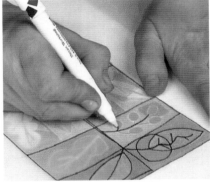

3 This template, for a wall niche in a garden, was originally drawn onto sheets of newspaper. Mosaic cannot be made up on newspaper, so the newspaper template has to be transferred to a sheet of brown paper. This can be done either by measuring the newspaper and reproducing the dimensions, or simply by placing it on top of the brown paper and drawing around it. It is easiest to make your templates on brown paper from the start whenever possible. Be sure you make the template on the matte side of the paper. Scribble over the back of the template to avoid possible confusion about which is the right side. It is also helpful to mark the top of the template.

4 Reproduce your reversed drawing on the matte side of the paper. If you drew it to scale in the first place, this task is easy, because you can simply scale off the original.

5 Once the design has been drawn on the paper, decide how you wish to divide up the mosaic into workable areas, keeping in mind what size area you like to work with and also the way in which the mosaic will finally be placed in position. As you can imagine, very large sections can be heavy and unwieldy. Draw your section lines onto the tracing paper. Code the sections, marking this code on the original side of the tracing paper. This is now your key drawing or fixing diagram.

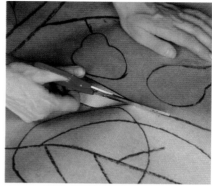

6 Mark the section code onto the back of the template paper. Include directional arrows, because—and this is especially true of abstract designs once the mosaic is covered with grout—it may not be obvious which way is up. Now you can begin to make the mosaic.

ENLARGING A DESIGN

A key part of the mosaic process is transferring your design from a nicely colored drawing that you have on a sheet of drawing paper into an accurate working template that shows you where to lay the tiles. If you are very confident about drawing, this may not seem difficult. But if you are doing a complex design that has taken a long time to get right on paper, then you will want to be able to enlarge it accurately. The useful part of this process is that the grid you draw to help transfer your design can be the same grid as you use to divide up the whole mosaic into sections to be laid in the indirect method.

TOOLS AND MATERIALS
❏ Ruler
❏ Pencil
❏ Charcoal
❏ Tracing paper
❏ Brown paper

I Make a working drawing at a small scale and decide on the best way to divide it up into manageable sections. It is not normally sensible to have sections that will be much bigger than about 23 inches (60 cm) square if you are working in vitreous glass or ceramic. If you are working in marble, which is a heavier material, the sections need to be smaller. These section lines will help as an aid to drawing your reversed design onto the brown paper.

2 Having decided how many sections your design will be divided into, draw these sections up onto tracing paper.

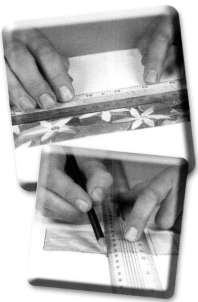

3 Trace your design onto the tracing paper and number or letter the sections. You will use this as the key when you enlarge the design. The numbers will also remind you of the sequence of the sections and so help prevent them from being fixed out of order.

4 Once this has been done, draw the section lines onto the matte side of a piece of brown paper with a pencil. Write the key numbers or letters onto the back of the brown paper (the shiny side).

5 Turn over the tracing paper so that you are working in reverse. With the matte side of the brown paper uppermost, draw out the reversed design. The section lines give you assistance in reproducing the original accurately. Simply make sure that the enlarged design intersects your grid at the same positions as on the tracing paper grid. With this grid as guide, you will find the original surprisingly easy to recreate. If you need more detail you could subdivide the grid into halves or quarters.

WORKING AROUND A FIXED OBJECT

It is easy to be deceived about the shape of something. You may measure a space and find that it is 1 yard by 2 yards (0.9 by 1.8 m) but, in reality, this doesn't tell you about all the swelling into the space of a wall, or the small area of molding around a fitted cupboard. These are just the sort of minor details that mean that your mosaic might not fit perfectly.

It is much easier to make a life-size template of an area, and be certain that your mosaic will slot exactly into place, than to spend the time troubleshooting when it doesn't. You might well wish to take a template of a bathroom floor, as this is the sort of room where mosaic is very often used.

In cases where it is not possible to move fixed pieces of sanitary furnishings, you will have to cut around them. The whole area of a floor will not fit on a single piece of brown paper. The template will have to be constructed from a series of sheets of paper, stuck together on the shiny side with masking tape.

TOOLS AND MATERIALS
❏ Scissors
❏ Craft knife
❏ Measuring tape
❏ Ruler
❏ Pencil
❏ Tracing paper
❏ Brown paper

1 Some areas are easy to measure out with paper, particularly where there are no fixed objects. Where you do encounter an object, such as the pedestal of this basin, you will need to measure out its position and dimensions so you can mark them onto the brown paper.

2 The outer dimensions of the front and sides of this pedestal are easy to measure. The difficulty with any template comes with curves, which are less easy to measure precisely. The secret of making successful templates around curved areas is to be unafraid of cutting away too much paper. It is easy to patch paper back in around a curve. The angles at the corner of this pedestal were quite easy to measure but, had they not been, they could have been made by cutting out the general shape of the pedestal and then patching pieces of paper back in to fit the shape.

3 Once you have the outer dimensions of the object, draw them onto the brown paper. To draw angled sections of a template, measure from the corners of the general outline to the point where the object ends and transfer these measurements onto the brown paper. Then cut out the area where the object stands.

4 Place the brown paper in position in order to check the accuracy of your template. If the space left for the object is too small, cut more away with a craft knife. If the space is too big, make a patch so that it does fit precisely.

3-Dimensional Effects

Some of the very earliest mosaics used three-dimensionality to tremendous effect. The Romans, for instance, were experts in creating lifelike images of both people and objects. The following techniques show how it is possible to create a similar impact with your designs.

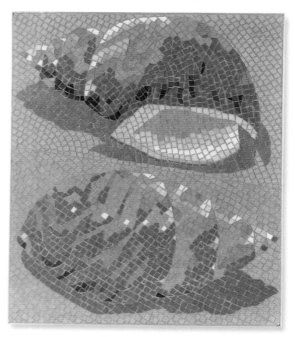

In order to create three-dimensional effects you have to use the tonal qualities of color. In the mosaic palette some colors are much better represented through a range of tones than others. It is easier to work in areas of the spectrum that have a good range of tones available. But tone alone is not enough. A sense of form needs to be created through the way the tiles are laid and how the grout lines flow, to accentuate the sense of three-dimensionality. This section is a guide to some tips and some pitfalls you might encounter. Once you have assembled your mosaic onto paper, use the indirect method to finish and fix it.

1 Produce a working drawing on tracing paper using colored pencils. To create a three-dimensional effect you need a subtle and gradual transition between tones. This does not mean you shouldn't use bright or intense colors, simply that your selection of colors should change gradually from shade to shade. The sketch will be reversed and a complex design may need some clarification in the reversed sketch. Color in the main areas of the design so that you can distinguish them from the background.

2 Using a permanent marker, transfer the reversed design to the matte side of a sheet of brown paper.

3 Before you glue the tiles to the paper, experiment in laying them in contrasting ways. Here, the tiles on the lower shell have been laid in straight lines across the design, producing a flat effect that is accentuated only by the grout. Follow the charcoal lines as a guide when you lay the tiles.

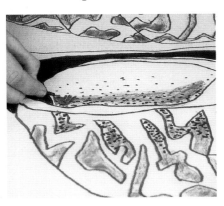

TOOLS AND MATERIALS
- ❑ Adhesive brush
- ❑ Tile nippers
- ❑ Tracing paper
- ❑ Colored pencils
- ❑ Selection of vitreous glass tiles
- ❑ Permanent marker
- ❑ Brown paper
- ❑ Water-soluble white craft glue

4 The tiles in the upper shell have been laid in a way that much better describes the form of the shell. They give a sense of the swelling shape the shell has. Once the tiles are positioned, it is possible to see how the shading and the lines of coursing of the tiles produce the sense of three-dimensionality.

5 Lay the tiles, applying a little glue to the paper at a time. Remember to keep the tiles flowing along your guidelines. Build the design up, working with a range of tones in both the brightly colored and the more muted areas.

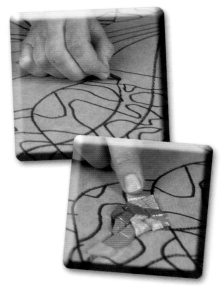

6 The tonal gradation of bright colors for the shell gives a sense of three-dimensionality, while at the same time the straight-laid background has the opposite effect of flattening the piece.

7 The impression of three-dimensionality is heightened by the contorted line that expresses the form of the shell and by the tonal variation of colors in the back and foreground.

3-Dimensional Surfaces

When tiles are laid in rows, the grout lines will naturally express a linear effect. However, three-dimensional objects, such as bowls, need special consideration to find the best way to express the form through line.

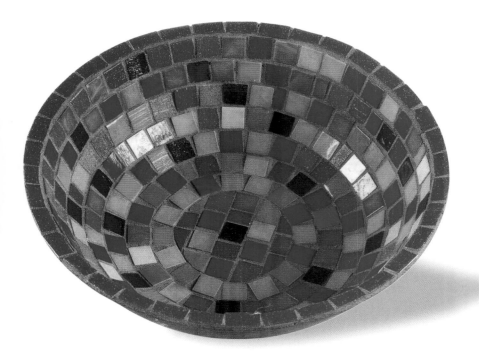

If you stick with simple, economical cutting methods, the shape of the tiles does not detract from the intrinsic form of the object. In this bowl, rings of tiles follow the flaring shape, making the mosaic look as if it fits effortlessly. If you do not properly consider the form onto which you are laying tiles, it is surprisingly easy to lay them in a clumsy way. Plan how the lines will flow to avoid strange cuts or "seams," and draw your laying plan onto the surface before you start.

TOOLS AND MATERIALS

❑ Paintbrush
❑ Spatula or small tool
❑ Grouting squeegee
❑ Sponge
❑ Materials
❑ Primer
❑ Slow-setting cement-based adhesive
❑ Latex admix
❑ Vitreous glass mosaic tiles
❑ Grout
❑ Rubber gloves
❑ Paint

I Prime the bowl so that a cement-based adhesive will stick easily to the surface. Once dry, make up some slow-setting cement-based adhesive. In this case, a latex admix has been combined with the adhesive in a 50:50 ratio with water, to give it extra grip onto wood. Ensure that the adhesive mix is stiff; if it is too wet, the tiles may slip.

2 Apply adhesive to the bowl in small amounts, using the spatula. Use the adhesive mixture to flatten out the lip of the bowl, so that the first ring of tiles can be capped by a ring of tiles to finish neatly at the top.

3 Follow the form of the bowl, laying the tiles directly into the adhesive in a series of rings. Always start from the top, so any problems with slippage will be immediately obvious. Be aware that adhesive is likely to squeeze up between the tiles in places where the angle of the bowl changes. On the flat base of the bowl, it is simpler to lay the tiles straight across, rather than cutting ever-smaller angles into the center.

4 Reapply adhesive to the lip of the bowl, and lay the border tiles. Leave to dry for 24 hours.

5 Once the mosaic is dry, grout the bowl. Where the sides curve up, it is easier to grout by hand rather than with a squeegee, but make sure you wear rubber gloves. Sponge off any surplus grout.

6 When the grout has dried, paint the outside of the bowl, and leave to dry.

7 The laying of tiles on this bowl was carefully planned to give a seamless transition from the flat bottom to the curved sides.

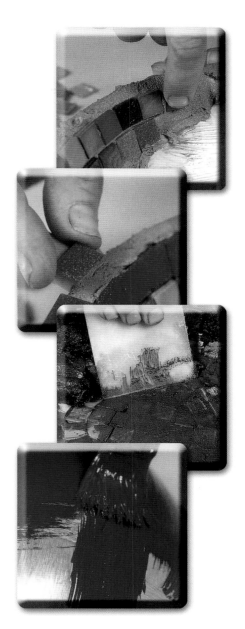

Useful Hints and Tips

This section contains a few pertinent pieces of advice based on the experiences of mosaic making. As soon as you start working in the medium of mosaic you will soon develop tips of your own and find ways of working that suit you. You may even discover better techniques than the ones given here.

Remember to experiment by trying out new ideas and not being frightened to have a few failures; you are likely to create dramatic successes.

What appears in this book as sets of rules and guidelines have in fact been acquired over the years through building up experience with different types of mosaic making, and by being prepared to experiment to find ever-better techniques.

Don't forget how useful it can be to produce a working drawing. If your design is complicated in terms of color or pattern it can be very helpful to work out potential problems on paper before you lay the mosaic. It is always quicker to produce and check a design on paper than it is to troubleshoot a half-completed mosaic.

Don't always work from a drawing. This may seem to contradict the advice above, but in fact, they go hand in hand. It is easy to stultify your creativity in the act of translating your work from one medium to another. To produce effective designs you need to think about the way mosaic works best, and allow the medium to lead the way. Do not be restricted by the constraints a paper design can impose.

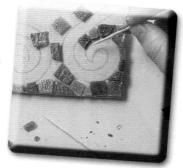

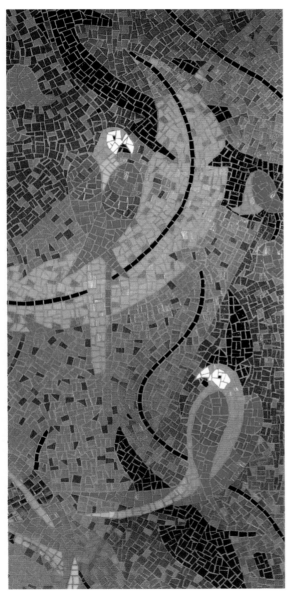

Look around you. Mosaic is an immensely rich medium. It offers you the opportunity to think about a huge variety of visual effects and themes, such as color, tone, intensity, pattern, stylization, and the choice between matte and reflective surfaces. All of these are constantly on display in a vast experimental way in your everyday surroundings and places you might visit. Once you have become sensitive to what you see, you can draw inspiration from all sorts of phenomena you might not previously have observed. If you are finding one area of work in mosaic difficult—tone perhaps, or color—it can help to study pieces that you think use these effects well. Some mosaicists keep a library of mosaic images.

Once your friends know you are interested in mosaic you will undoubtedly receive lots of mosaic postcards. Don't think you can derive inspiration only from images of mosaics though. It can be helpful to collect any kind of picture you find interesting or inspiring. You might find particular color combinations, or shapes, or ways of composing an image, useful as reference material. Printed material can show how to derive a huge number of effects and approaches from a limited palette of colors. Don't be afraid to imitate effects from other media.

Keep an eye on color. Remember that there is often a variation between different batches of the same color tiles from a different or even the same supplier. If you are working on a large mosaic with one primary background color, make sure you have enough material before embarking on the mosaic. It can be very frustrating, and look rather strange, if the background color changes slightly halfway across a piece. If this does happen, however, it can be remedied. Rather than soaking off all the mosaic and starting again, randomly peel off some tiles in the area you have already laid, and make a mixture of the old and the new color batches across the whole area, to give an interesting and flickery effect.

Mix media. In order to explain how some of the techniques in this book work, and what the effects given by the various materials are, the projects have tended not to mix media very much. This is not intended as a guide to how you should work. Combining materials can be an exciting way of extending the color and surface qualities of any range. When working direct, as in Katie Hall's panel shown here, you can combine almost any materials. You can also mix media when working indirect, as long as the materials are all of approximately the same thickness.

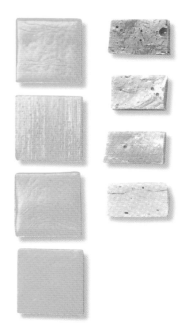

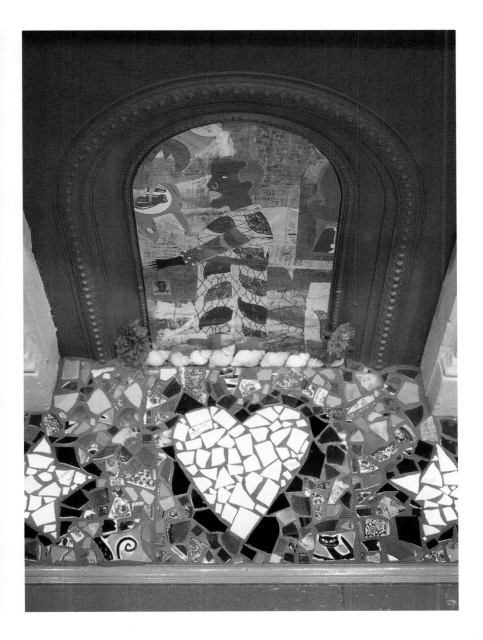

Projects

The projects in the following chapter show imaginative and inspiring examples of the wide range of methods, styles, and applications used by modern mosaic makers. Of course, there is no need to follow the examples exactly—you can add ideas of your own. Choose your favorite colors, experiment with different materials, and adapt the designs to fit your own requirements. The possibilities are endless.

Exterior Pebble Step

The House of Mosaics was built in the late fourth century B.C., a Hellenistic Eretrian house that was once home to a ruler. This mosaic is one of two pebble panels that decorated the floor of the andron, a room in which symposia and banquets were held. The design has volutes and borders with bands of ivy leaves. The central rosette has a rose-colored center encircled with pairs of coils. A delicate simplicity underlies the design, giving an immediate appeal to the viewer.

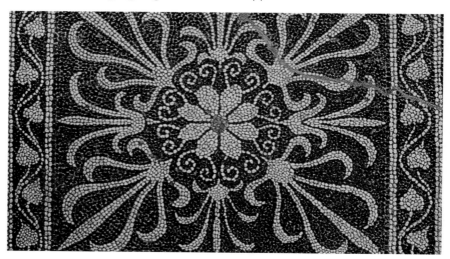

TOOLS AND MATERIALS

- ❑ Protective wear
- ❑ Paper
- ❑ Felt-tip pen
- ❑ Polyethylene sheeting
- ❑ Fiber netting
- ❑ Scissors/craft knife
- ❑ Palette knife
- ❑ Water and cement containers
- ❑ Cement adhesive
- ❑ Cement

- ❑ Red sand
- ❑ Cloths
- ❑ Trowel
- ❑ Masonry brush
- ❑ Masonry cleaner
- ❑ Brush
- ❑ White pebbles
- ❑ Small rose-colored pebbles
- ❑ Larger rose-colored pebbles
- ❑ Assorted small black pebbles

Many pebble mosaics are created in situ or use a reverse or double-reverse method. However, small-sized pebble mosaics can be made using this direct method. The design should be no larger than 4-5 square feet (0.5 sq. m), since pebbles are fixed to a fiber net and must remain manageable. For the project a semicircular stepped area of 39 inches (1 m) diameter was used.

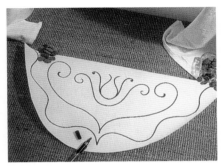

1 Draw the design on a paper template to fit a predetermined space. A simple design of curved lines was chosen to emulate the ancient Greek vegetal motif. Strengthen the design with a thick felt-tip pen.

2 Put a layer of plastic sheeting and a layer of netting over the drawing. The design should remain very visible. Make up a little of the cement adhesive by adding water and apply to the back of each pebble before affixing to the net.

3 Surround the mosaic with a frame of larger rose-colored pebbles. Use smaller pebbles to create and define the volutes.

4 Use slightly elongated pebbles for the linear drawing.

5 Use tiny, dark rose-colored pebbles for the central bud and some small elongated black pebbles to give a more delicate and tightly tesselated image.

6 For the white background use white pebbles to follow the outlines wherever possible before completely filling in. When completed, cut the mosaic close to its outer border.

7 The prepared semicircular step should have an indentation of 3/4 inches (2 cm). Make a quantity of cement adhesive and smoothly trowel over the area to a thickness of 1/4 in (6 mm). Drop the mosaic gently into position. Lightly tamp the surface into the mortar using a piece of wood and a hammer. Take care with the smaller pebbles not to let the mortar rise more than halfway up each pebble. Leave the mosaic overnight.

8 Make a grout of three parts fine red sand and one part cement. Add water slowly to make a thickish mortar. Rub the mixture into the surface, grouting the whole design and the edges. Rub clean using cloths and a masonry brush, then leave to cure under polyethylene sheeting or wet cloths for two to three days before final cleaning and washing with masonry cleaner and water.

The steps are often cluttered with pots of plants and trailing vegetation. They lead down to an area of garden used for outside entertaining, both during the day and in the evening when the white pebbles lightly gleam in the moonlight. Talk often drifts long into the night, recalling the symposia rooms of the original mosaic in Eretria, Greece, where, no doubt. similar conversations were heard and many of the same questions were asked and again left unanswered.

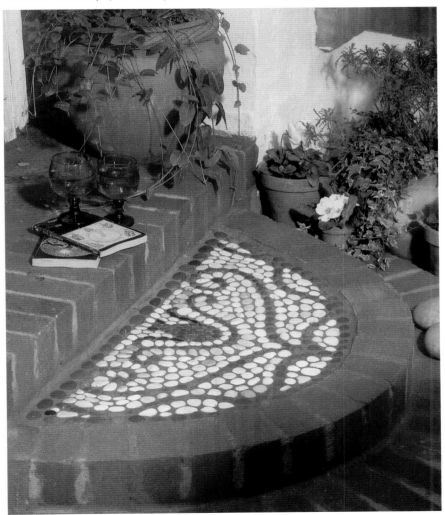

Decorative Floor Panel

Inspiration: ivy leaves. Floor panel from Carthage. Tunisia, second century A.D., after a copy of the work of Sosos of Pergamum. Now in the British museum, London, England.

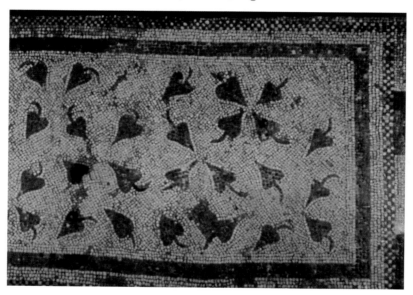

One of the most famous of Greek mosaicists in the second century B.C. was Sosos of Pergamum (Bergama, in present-day Turkey). Renowned examples of his work include "Doves Drinking at a Bowl," and the "Unswept Floor" (asaroton) where detritus from a banqueting table is depicted scattered on the floor. Images include fishbones, lobster claws, nutshells, and even a mouse. Many copies of the Sosos originals were made and examples can be seen in Emperor Hadrian's villa at Tivoli and in the Vatican museum in Rome.

In this mosaic, a copy made in Roman times, black ivy leaves (an image sometimes attributed to the fan of Venus) are randomly strewn over a white ground. They are surrounded by a black band of tesserae and a simple black-and-white checkered border. A wonderful rhythm of shape and direction is created by the stems of the leaves, giving a slightly humorous lilt and life to the whole area.

TOOLS AND MATERIALS

- ❏ Protective wear
- ❏ Paper
- ❏ Felt-tip pen
- ❏ Polyethylene sheeting
- ❏ Fiber netting
- ❏ Mosaic nippers
- ❏ White household glue
- ❏ Spatula
- ❏ Tweezers/dental probes
- ❏ Craft knife
- ❏ White tiles 6 inches (15 cm)
- ❏ Cement adhesive

- ❏ Ready-mixed cement grout
- ❏ Notched trowel
- ❏ Cloths
- ❏ Patio cleaner
- ❏ Brush
- ❏ Piece of wood approx. 2 feet 2 inches
 x 5 inches (65 x 13 cm) for tamping
- ❏ Hammer
- ❏ Black ceramic mosaic tiles
- ❏ White ceramic mosaic tiles
- ❏ Plain silver smalti
- ❏ Rippled silver smalti

1 The drawing was done to size to fit a central space 4 x 2 feet (122 x 61 cm) on a kitchen floor of plain white tiles. Eight leaves were drawn in two groups of four, with a drawing of a running lizard in each. The border was marked by three grid lines that helped when constructing the geometric framing tesserae. The drawing was strengthened by felt-tip pen lines. This was then covered by a polyethylene sheet and then the fiber net. The drawing should remain clearly visible through these layers.

143

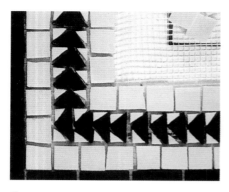 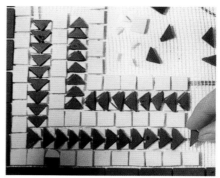

2 Fix whole black mosaic tiles to the surface netting to stabilize the mosaic, and follow by an inner line of white quarter-tesserae. Cut large triangles diagonally from quarters of black mosaic and fill in the spaces left with white triangles of half this size. Triangles need perseverance in cutting!

3 Build up the border with two inserts of triangles running in opposite directions; this will accentuate the running theme of the two chasing lizards. Add extra grid lines if necessary to help when constructing the border.

4 Choose to work on the leaves or the lizards next. Leaves: outline the shape with a single line of white quarters and fill in with Opus Palladianum, a random tesselation.

5 Cut one black tessera into quarters. Outline the leaf with one line of black tesserae. Take extra care at the tip of the leaf to give good definition.

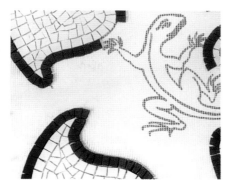

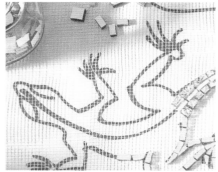

6 Outline all the leaves similarly to give a strong binding form.

7 Lizards: Use small squares of rippled silver for the tail and plain for the body.

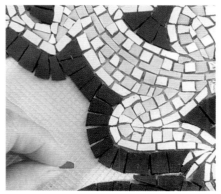

8 Take care in cutting the feet and head shape to give a good silhouette when viewed against the black background. Shape the tesserae to give a good tesselation. It is important when working on small-scale images to give good delineation, especially with a limited palette of color.

9 As with the leaves, run a line of tesserae around the lizard's body before filling in the remaining spaces with fairly uniform squares wherever possible, always following a form. When complete, leave the mosaic to dry for at least 24 hours before cutting the net away from the edge of the mosaic as close as possible to the black framing tiles. The mosaic is now ready for fixing.

10 Prepare the cement bed by mixing a quantity of cement adhesive and trowel it level and smooth to ¹/8 inch (3 mm) in depth. Carefully use the notched trowel over the surface to ensure a good gripping adhesion for the mosaic. With help, carefully lower the mosaic on net into its bed. Using the rectangle of wood, slightly wider than the mosaic, gently tap the mosaic level all over, taking great care over the slightly raised area of the lizards. Leave to set overnight before grouting the work with a ready-mixed cement grout, and clean with the patio cleaner and water as instructed.

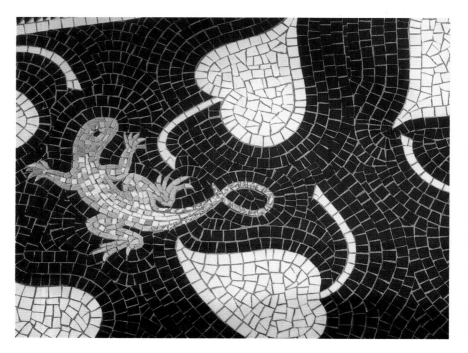

Jeweled Trinket Box

A delicate combination of glass gems and colored glass backed with silver leaf and mixed with small silver beads makes this tiny trinket box almost a piece of jewelry in itself! A beautiful addition to any dressing table.

TOOLS AND MATERIALS

- Small, circular ceramic trinket box, about 4 inches (10 cm) in diameter
- Glass gems in different shades of blue
- One larger blue glass gem
- Clear blue stained glass
- Silver leaf or faux silver leaf (not tin foil)
- Lots of silver beads
- Ceramic tile adhesive
- Small plastic glue spreader
- Fine tweezers (optional)
- Protective eyewear
- Work gloves
- Newspaper or scrap paper
- White grout (unsanded)
- Blue grout coloring powder, or acrylic paint
- Rubber gloves
- Disposable container
- Stirring stick
- Sponge/dry rag

1 Begin with the lid and apply a layer of adhesive to the surface with the plastic spreader. While this is becoming tacky, apply a layer to the back of the large gem and then stick it into position in the center of the lid. Once this is firmly in place, apply an additional band of adhesive quite thickly around it; let it dry out a little, then surround it with a ring of the silver beads. It is too tedious to butter each bead individually, so the glue bed needs to be quite thick to hold them all firmly. Stick the beads down so that the holes point to the sides and are hidden from view.

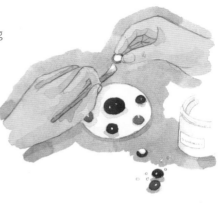

2 Arrange a selection of six of the smaller gems evenly around the centerpiece, making sure that any duplicated colors are kept away from each other. Apply more adhesive to their backs and stick them down. Make sure you have left enough room around all sides to add a ring of silver beads. When they are all in place, surround them with beads in the same way as you did for the central gem. A pair of fine tweezers may come in handy for picking up and placing the beads.

3 Use your nippers to break the silver-backed glass into tiny random fragments, wearing protective gloves and eyewear. Reapply adhesive to the base if necessary, then butter the glass pieces and fill the remaining spaces on the lid with them, silver side down. Use the tweezers again if you need to.

4 When the lid is finished, move onto the box itself. Spread a thin band of glue (deep enough to hold beads) around the top edge of the box and allow it to dry slightly. Stick a ring of beads right around this top rim, making sure that they do not come too high up and interfere with the fit of the lid. Wait for them to dry to a stage where they don't move when you touch them; keep an eye out for any slippages, then turn the box upside down and repeat the process on the bottom edge. Again, make sure that the beads don't stick up too far and prevent the box from standing flat.

5 Replace the lid on the box and position your last six gems so that they correspond with the position of the gems on the lid, having first applied adhesive to the base and to the gems themselves. Frame each gem with a vertical strip of beads on either side, using the same method as before. When every gem has been framed, fill in the spaces between each one, using the glass fragments. You can also fill in the corners between each gem and the bead frame, but it's not vital as the gaps can be filled just as well with the colored grout. Allow the finished mosaic to dry naturally for forty-eight hours.

6 Put on rubber gloves and, using quite a lot of coloring, mix up a strong shade of blue grout (see the instructions on pages 30-33). Use your fingers to gently rub the grout over the lid and the box, covering each one separately. Remove the excess with the dampened sponge and polish with a soft dry rag after 15 to 20 minutes.

Chair

Covering a chair in mosaic is a slightly more ambitious project, but satisfying nevertheless. The smoother and finer your mosaic, the more practical your chair will be for sitting on, but it could also be used in a bathroom or bedroom to drape clothes or towels over or even as an unusual plant stand!

TOOLS AND MATERIALS

❏ Sturdy wooden chair with a round seat
❏ A good quantity of tesserae incorporating patterned and plain blues and some white
❏ Craft knife
❏ Washable felt-tip pen
❏ Tile nippers
❏ Ceramic tile adhesive
❏ Small plastic glue spreader
❏ Protective eyewear and gloves
❏ Blue acrylic or gloss paint
❏ Sanded grout in a vivid blue (or color of your choice)
❏ Newspaper or scrap paper
❏ Rubber gloves
❏ Disposable container
❏ Stirring stick
❏ Sponge
❏ Dry rag

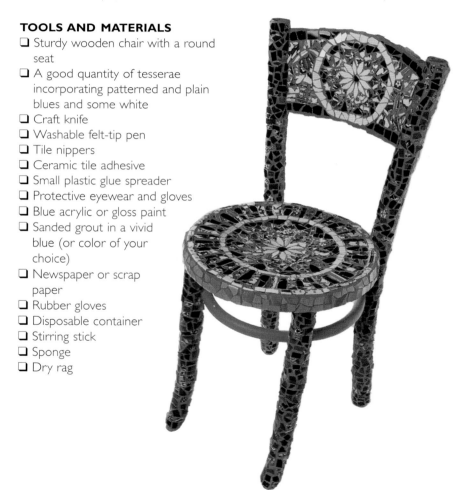

1 Draw the design on the flat surfaces of your chair with a washable felt-tip pen. The design consists of a small 12-petaled flower contained within a larger one. The points of the inside flower correspond with the "dips" in the outer one. The flowers are then contained within a banded circle. On the seat, alternating patterned and plain strips radiate out from the circle.

2 Put on the protective eyewear and gloves and using the tile nippers nibble out a small circle for the center of the first flower on the seat in dark blue, and then 12 thin petals in white. It is very important that you use tesserae that are the same depth to ensure smoothness, especially if you intend to use your chair to sit on.

3 Apply a layer of adhesive to the flower area on the chair, then butter the individual tesserae and stick them into place. Fill the next flower design with a mosaic of random tesserae in patterned ceramic and complete the circle with plain dark blue tesserae placed between the petals. Finish it off with a band of white. Make the radiating lines on the seat a little wider at the top than the bottom so that they fit neatly around the central circle. Alternate dark blue lines with patterned ones and leave a space round the outside of about $^1/_2$ inch (13 mm) for a white border.

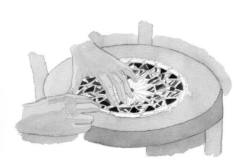

4 Use the same techniques on a smaller scale for the flowers and circles on the front and back of the chair. Let the edges of the circle come flush with the top and bottom of the backrest. Add a border there in dark blue and fill the remaining space with patterned tesserae.

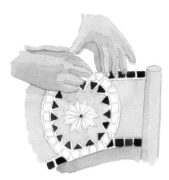

5 The spindles and legs of the chair are covered in a mosaic of dark blue tesserae. You will need to cut them quite small to fit comfortably around the curve of these areas. Similarly curved tesserae taken from cups or bowls will also help here. Even though it is difficult, try to make sure you do the insides and tops of the legs as well as you can. You don't need to mosaic under the seat.. Take the mosaic down the legs to about 1/2 to 3/4 inch (13 to 19 mm) from the bottom and use circular medallions for the tops of the chair spindles.

6 When the chair is completely covered, leave it to dry naturally for 48 hours before grouting. Put on the rubber gloves and mix up a vivid blue grout (see the instructions on pages 30-33), using a fair amount of powder or paint to get a strong color. You will need a lot of grout to cover the whole chair. Apply the grout thoroughly with your hands or your chosen grouting tool, making sure you rub it really well into every part of your mosaic.

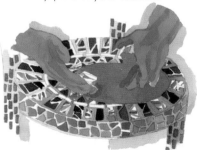

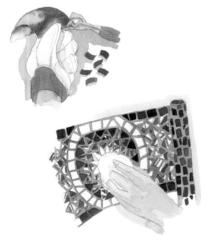

7 As soon as the whole chair is fully covered, begin wiping off the excess immediately with a damp sponge. Wipe off the remaining chalky haze with a dry rag and paint the unmosaiced areas if you like.

Right: *For reference, a mosaic with a similar design is shown.*

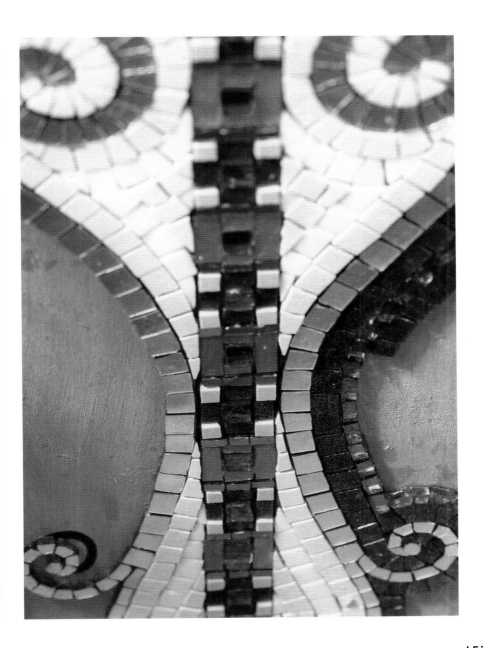

Roman Swirl Mirror Frame

The swirly design around this frame is a classic Roman pattern, often used for decorative borders on floors. The pattern is the same whichever way you look at it with both colors following the same path. Many examples of this kind of repeated pattern were found in Roman art and these are known as "key patterns."

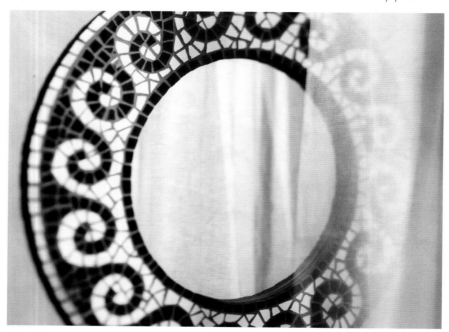

TOOLS AND MATERIALS

- ❑ Tracing paper
- ❑ Wood (or ready-made wooden frame)
- ❑ Ceramic tiles
- ❑ White or yellow craft glue
- ❑ Tile adhesive
- ❑ Grout
- ❑ Mirror
- ❑ Pencil and marking pen

- ❑ Jigsaw
- ❑ Mask and safety glasses
- ❑ Tile cutters
- ❑ Mosaic nippers
- ❑ Palette knife
- ❑ Bucket
- ❑ Squeegee
- ❑ Sponge and dry cloth
- ❑ Paintbrush

1 Begin by preparing the surface of the mirror frame. Mix a solution of craft glue and water (1 part glue: 4 parts water) and apply with a paintbrush. The frame used in this project was already made, but a simple frame can be made by cutting a circular shape from a wooden board, and cutting a smaller circle from the center using a jigsaw. The mirror can later be held into place on the back of the board, by positioning tacks around the circular cutaway and bending them firmly over the mirror.

Examples of interlocking key patterns, in which two colors follow the same shape.

2 Trace the design onto the wooden frame. You may have to modify the swirls to fit your frame; this can be done with the help of a compass. Mark the outlines clearly with a hard lead pencil or marking pen.

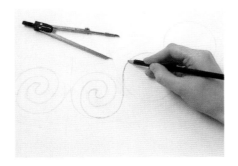

3 Break up the ceramic tiles into pieces, without worrying too much about accuracy at this stage as the tesserae will need to be nibbled into specific shapes. Choose two colors to work with that complement each other and keep the colors in separate piles as you work.

4 Apply tile adhesive to the wooden frame using a palette knife, working in small sections to avoid the adhesive drying out and becoming lumpy. Stick the tesserae into place, starting with the outside edge working with one color at a time, and nibbling the tesserae into shape as you go along. When all the tesserae have been secured in place, allow the project to dry overnight.

155

5 In a bucket, mix up a dark gray-colored grout. This can be done with a precolored grout or color the grout yourself by adding a dark stain or some acrylic paint to the water before adding it to the powdered grout. Apply the grout using a palette knife, spreading generously over the mosaic and pushing down in between the spaces. Wipe off the excess with a squeegee and smooth out the edges of the frame.

6 Clean off any other leftover lumps of grout with a damp sponge and let sit until the mosaic surface is dry to the touch, then polish with a dry cloth. Finally, secure the round mirror into the frame—it is best to have the mirror professionally cut to size—and then hang it in place.

Right: *For reference, a mosaic with a similar design is shown.*

ROMAN SWIRL MIRROR FRAME

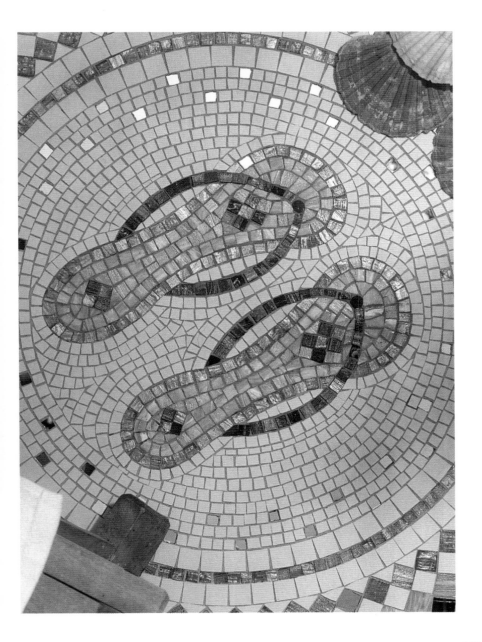

157

Byzantine Box

The jewel-like colors and patterns of this dazzling box were inspired by the great Byzantine mosaics, where artisans used simple shapes and bright colors to great effect. Traditional gold smalti is very expensive. In this project the box has been covered in gold paper, which shows through the clear glass, giving the effect of shimmery gold tesserae. Stained glass has been used as an alternative to the more traditional colored smalti. If you cannot get hold of real stained glass, paint the undersides of clear glass pieces with special glass paints.

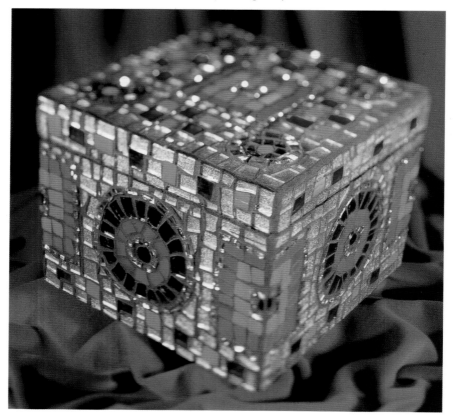

1 Enlarge and modify the design to fit the shape and size of your box. Cover the outside of the box with gold paper, carefully sticking it down with craft glue or spray adhesive. Smooth out any creases and make sure the edges are stuck down well. Trace and transfer the design onto the outside of the box and clearly mark the outlines with a marking pen.

2 Cover the box with gold shiny paper before you begin the mosaic. Stick it down with craft glue and smooth out any creases as you go along. Do not fold the paper over into the inside of the box as this will stop the lid from fitting properly; instead, trim the paper at the edge and stick it down securely. Any color of paper can be used, but shiny or metallic paper is the most effective as it helps the light reflect back through the glass. Aluminum foil can also be used to achieve glittering results.

3 Break up the tesserae into approximate sizes and keep the colors in separate piles. Be very careful when cutting the tesserae as glass is extremely sharp and can be dangerous; wear a mask and safety glasses while cutting and work outside if possible. Stained glass can be cut in the same way as mirror or ordinary glass, using a glass scorer and glass cutters.

TOOLS AND MATERIALS
- ❏ Tracing paper
- ❏ Marking pen
- ❏ Shiny gold paper
- ❏ Epoxy resin
- ❏ Clear glass
- ❏ Stained glass
- ❏ Wooden box
- ❏ White or yellow craft glue
- ❏ Spray adhesive
- ❏ Grout
- ❏ Mask and safety glasses
- ❏ Scissors or craft knife
- ❏ Mosaic nippers
- ❏ Glass or tile cutters
- ❏ Palette knife
- ❏ Squeegee
- ❏ Sponge
- ❏ Lint-free cloth
- ❏ Toothpicks

4 Work in a well-ventilated room and stick the tesserae to the box with a small amount of epoxy resin adhesive. Begin working on the top of the lid; start at the outside edge and work inward. Use small mirror pieces to outline the edges of the shapes. Fill the shapes with stained glass, which can be nibbled into exact shape using mosaic nippers. Stick clear glass tesserae onto the gold paper to fill in the background; this is quite painstaking work, so use a toothpick to help create even spaces between the glass pieces. When the top is complete, work around the edges of the lid and allow it to dry while you work on the bottom section of the box.

5 When working on the bottom section, check that the pattern lines up with the pattern on the sides of the lid. Make sure that the tesserae do not come too high up the sides of the box and obstruct the lid. When all the tesserae have been glued in place, let the box dry for a couple of days, until all the glue is completely clear and dry.

6 Grout the mosaic using a dark-colored grout, which will help to bring out the bright jewel-like colors of the tesserae. Wipe away any excess grout with a rubber squeegee and a damp sponge. Do not disturb the box until it is dry to the touch, then give it a final polish with a dry lint-free cloth.

Use an eclectic mix of glittering tesserae, sparkling glass, and twinkling tiles in rich jewel-like colors to create dazzling effects on different boxes.

Right: *For reference, a detailed image of a mosaic with a similar design is shown.*

Golden Candlesticks

These bright modern candlesticks are a great starter project. They are of a manageable size and you can use pieces of broken tiles, old china, or just about anything else that you like or happen to have lying around. Add a few pieces of reflective or shiny tesserae and these candlesticks will look fantastic in dim light.

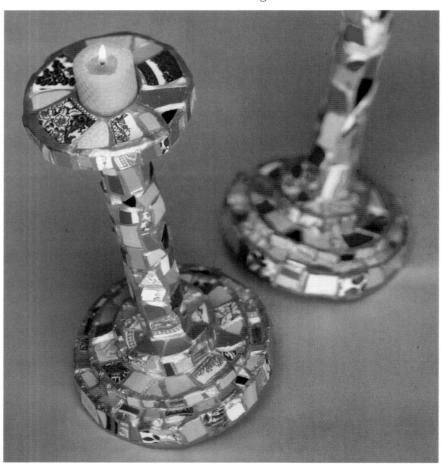

TOOLS AND MATERIALS
- ❑ Sections of circular wood pole or prefabricated candlesticks
- ❑ White or yellow craft glue
- ❑ Multicolored ceramic tiles
- ❑ Tile adhesive
- ❑ Powdered white grout
- ❑ Gold paint
- ❑ Sandpaper
- ❑ Mask and safety glasses
- ❑ Tile cutters
- ❑ Mosaic nippers
- ❑ Palette knife
- ❑ Bucket
- ❑ Sponge and cloths
- ❑ Paintbrushes

1 First find a suitable candlestick base to work on—in this instance a base was specially designed and made by turning a section of wood on an electric lathe. You can work on any simple candlestick that has no unnecessary grooves, bumps, or ridges on the column. Rub off any varnish or paint on the base with coarse sandpaper and apply a solution of craft glue and water (1 part glue: 4 parts water) with a paintbrush and allow to dry thoroughly.

2 Break up a selection of ceramic tiles of varying colors and patterns. The pieces need to be fairly small as they have to fit around a curve, but don't worry about the shapes at this stage as they will need to be nibbled into exact shapes later on. Mix up all the tesserae into one big pile.

3 Select the tesserae at random from the pile, nibbling into shape as required. Apply a small dab of tile adhesive to' the back of the tesserae before pressing them firmly onto the wood. Starting at the top and working down, work on one section of the candlestick at a time, so you always have a secure part to hold onto while you work. Once all the tesserae are in place let the candlestick dry overnight.

4 Mix up the grout in a bucket—white grout is ideal but it doesn't matter too much since the grout will be painted later. Apply the grout with a palette knife, pushing down in between the spaces and smoothing off any rough edges around the column. Wipe away any excess grout with a damp sponge and polish with a dry lint-free cloth when the grout is dry to the touch. Allow the candlestick to dry thoroughly for at least two days before the next stage.

5 Add the finishing touches to this candlestick by painting the grout with a shiny gold paint. Apply the paint with a fine artist's paintbrush to the spaces in between the tesserae. It is quite a tricky job, but any stray drips of paint can be easily wiped off with a damp cloth. Allow the paint to dry thoroughly before using the candlesticks. Of course, if your preference is for a different color scheme to suit your room, silver paint or any other metallic color would be equally effective.

Right: *For reference, a mosaic with a varied color and design scheme is shown.*

Mexican Inspiration

The complex history of Mexican civilization and culture can be traced back at least 3,000 years. Many ancient artifacts still survive to this day, a testament to the highly skilled artisans and great craftsmanship of ancient Mexican civilization. These different cultures, emerging at separate times throughout early history, were linked not so much geographically, but by the shared beliefs in powerful gods and the striking similarities between art and rituals, as depicted in the many examples of carving and inscriptions.

Mayan and Aztec art have been very influential in the shaping of Mexican art as we know it today. Rediscovered in the nineteenth century, Mayan architecture and art have been much admired and are considered to be the most accomplished of ancient Mexican cultures. Detailed inscriptions and carvings inside tombs relate to major historical events and help to explain beliefs and time cycles of the Mayan period. Aztec art, although vibrant and full of life, appears obsessed with deathmasks of human and animal skulls. Sacrificial knives and depictions

of demons and warriors all show a preoccupation with horror and combat. But it was an era where the arts and crafts were greatly encouraged, and much of the work involved the use of gold and cut, polished jade, with turquoise and other precious stones used to create fabulous mosaics.

Mexico won independence from the Spanish in 1821, and the following years, until the revolution of 1910, were a time of much political upheaval and social redress. A later period of renaissance saw a resurgence of the fine arts, with artists such as Frida Kahlo, Diego Rivera, Jose Clemente Orozco, and David Alfaro Siqueiros leading the way. Rivera, an influential muralist, received commissions for frescoes from the government and attempted to create a style reflecting both the history of Mexico and the socialist spirit of the revolution. Siqueiros, another muralist, made cartoons for the mosaics of the "rectorado" building at the University in Mexico City. Also at the university, covering the exterior of the library building, is a mosaic by Juan O'Gorman depicting Mayan hieroglyphics and Aztec motifs.

Today, art and color are an essential part of popular culture and life in Mexico, and modern-day folk art and crafts are more likely to be found in markets and in people's homes, rather, than in galleries.

167

Cactus Wall Panel

The combination of many different kinds of tesserae in this picture has created a wonderful effect. The use of fiery colors and the choice of stained glass for the sun against the vibrant blue of the sky combine to give off a feeling of shimmering light and heat rising from the arid landscape. There are endless possibilities for creating interesting combinations of tesserae in a project such as this. Use a mixture of terra-cotta, unglazed tiles, floor tiles, mirror pieces, ceramic, pebbles, and bright shards of stained glass.

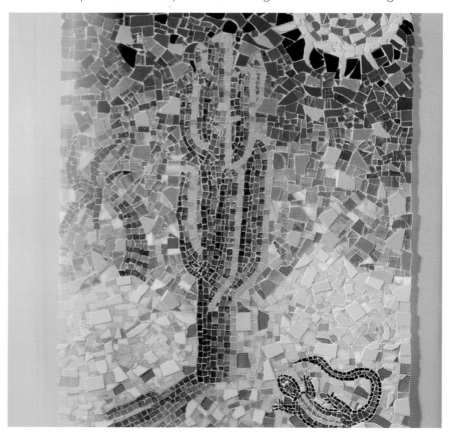

TOOLS AND MATERIALS

- ❏ Tracing paper
- ❏ Marking pen
- ❏ Ceramic tiles
- ❏ Vitreous glass tesserae
- ❏ Stained glass
- ❏ Sturdy wooden board
- ❏ White or yellow craft glue
- ❏ Tile adhesive
- ❏ Grout
- ❏ Mask and safety glasses
- ❏ Glass or tile cutters
- ❏ Mosaic nippers
- ❏ Palette knife or small trowel
- ❏ Squeegee
- ❏ Rubber gloves
- ❏ Sponge and scourers
- ❏ Lint-free cloth

1 Prepare the board by sanding away any sharp edges and applying a solution of craft glue and water (1 part glue: 4 parts water). Draw or trace the design onto the wood and clearly define the outline with a marking pen. Mark the basic colors in the appropriate sections.

2 Place a sheet of tracing paper over the template. You can make the template any size so that the panel will fit comfortably in your wall space. Using a hard lead pencil, draw over the outline of the design. Turn the tracing paper over and rub over the outline with a soft lead pencil. Turn the paper over again and place it onto the wooden board, securing it with masking tape. Use the hard lead pencil to redraw over the outline, pressing hard so that the pencil marks on the reverse side leave an outline on the board. Define the outline clearly with a marking pen.

3 Mix your colors. Cut up the tesserae. Mix together tesserae of different materials, shapes, and sizes, and of varying shades of the same color. Pile these together to be selected at random as you go along, but keep different colors separate. Trim the tesserae to the exact size required with the mosaic nippers.

4 Build up the picture. Working in the direct method, stick the tesserae onto the board with the tile adhesive, spread only a little at a time to avoid drying out before use. Work on one section of the image at a time, doing the details and foreground first, and the background later. Place tesserae of different materials next to each other: stained glass next to ceramic tile or next to vitreous glass, for example, to give texture and variety to the surface.

5 Complete the background. When laying the background tesserae, graduate the tones of the tesserae as they become nearer to the sun, to give a sense of heat rising. Bring warm tones into the sand and outline the lizard with small dark tesserae to really make its shape stand out. When all the tesserae are in place, let the mosaic dry flat for a couple of days.

6 Apply the grout. Mix up a light brown grout in a bucket and spread over the mosaic using a small trowel or palette knife. Wipe off excess grout with a squeegee and smooth away any rough edges.

7 Clean off any remaining grout with a damp sponge—use a scourer for any stubborn spots—and polish with a dry lint-free cloth when the grout is dry to the touch.

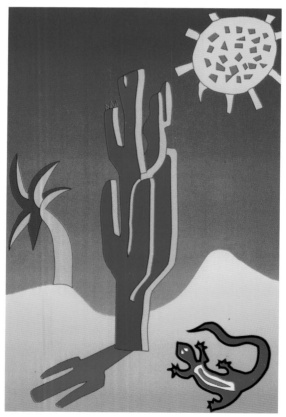

Experiment with combinations of different-textured tesserae. Try rough, unglazed tiles for the sand against smooth shiny blues for the sky to add an extra dimension. You could also add a few multicolored pieces of crockery for extra interest within the details.

Aztec Serpent Wall Panel

The idea for this panel was inspired by an ancient Aztec turquoise serpent. The original serpent is believed to have been the decoration on a headdress. In this version, however, the serpent is nearly 10 feet (3 m) long, a little too big to wear on a hat. While the original Aztec version of this snake is made up of turquoise stone, in this version ceramic tiles have been used. Various shades and thicknesses of the tiles give the serpent its texture and the triangular mirrored pieces create a snakeskin effect.

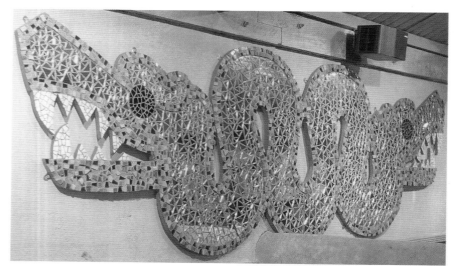

TOOLS AND MATERIALS

❑ Tracing paper
❑ Wood
❑ White or yellow craft glue
❑ Water
❑ Mirror
❑ Ceramic tiles
❑ Acrylic paint
❑ Grout (powdered)

❑ Jigsaw
❑ Mask and safety glasses
❑ Tile or glass cutters
❑ Mosaic nippers
❑ Palette knife
❑ Rubber gloves
❑ Paintbrush
❑ Clean, dry cloth

1 Prepare your base. Enlarge the design to the required size and trace it onto the wood. This design will work well in any size. The serpent pictured is nearly 10 feet (3 m) long, however, which is not a practical size for most domestic environments. Unless the room is large enough to accommodate it, and there is sufficient distance from which to view the work, a smaller version would be much more suitable. Using a jigsaw, carefully cut the wood following the outline of the design. Prepare the surface of the wood by applying a craft glue and water solution (1 part glue: 4 parts water) with a large paintbrush.

2 Cut your tesserae. Cut the tiles into approximate sizes; these can be nibbled into shape later. To create the turquoise color use a mixture of blue and green tiles. To make sure of an even distribution of the various shades of tesserae, cut equal amounts of each of the different tiles and mix them together in a pile.

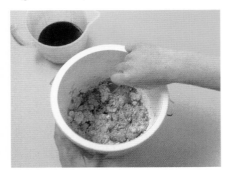

3 Lay the colored tesserae. Using the direct method, start from the outside edge and work inward, selecting tesserae at random from the pile. Stick them onto the wood using craft glue. If any of the tesserae need to be nibbled into more precise shapes, use the tile nippers. Carefully following the outline of the design, first apply all the blue and green tesserae, then the black for the eyes and white for the teeth. Let dry overnight. The outside edges need to be firmly set before you start working on the mirror sections so that the tesserae do not come off if the project is moved or leaned on.

4 Add the mirror tesserae. Cut the mirror into small triangles. If you are working with a large sheet of mirror, first cut it down into manageable sized squares, approximately 6 × 6 inches (15 × 15 cm) and then into triangles. Mirror can be cut in the same way as ceramic tiles; first score a line across the surface, and then break the mirror using the mouth of the cutters. At this stage it is essential to wear gloves as the edges of the mirror triangles are extremely sharp. Stick them to the wood using craft glue. Don't worry too much about leaving uneven spaces between pieces, as in this project the grout itself plays a large part in the overall effect. When all the tesserae are in place, allow the mirror to dry thoroughly for a couple of days before grouting.

5 Grout the mosaic. There are two different-colored grouts used in this project; terra-cotta for the ceramic and turquoise for the mirror sections. To color grout, mix up a solution of water and acrylic paint. Add this solution to powdered grout and mix in the usual fashion. Bear in mind that the color will be lighter when the grout dries out and more paint may need to be added to make the color stronger. It is worth doing a few samples before grouting the real thing. First grout the ceramic sections using a dark terra-cotta grout. Work from the outside edge inward, being careful to stop at the edge of the mirror section. Apply the grout with a palette knife, pushing the grout into the openings. Wipe off any excess grout using a clean damp sponge. Let dry before repeating the process for the mirrored sections, this time using turquoise grout.

6 Paint the base. When the grout is dry to the touch, polish off any remaining grout with a dry cloth. Finally, paint the edge of the wooden base with an acrylic paint, mixed to the same color and shade as the terra-cotta grout.

7 Color grout by adding dyes, pigment, or in this case, ordinary acrylic paint. Mix up the paint and water to a thick consistency like molasses and add it to the powdered grout. At first the paint mixture tends to make the grout streaky, so keep on mixing until the color is even throughout. Remember that the color will be lighter when it dries so it is worth making up a sample beforehand to check the color.

Right: *For reference, a similar mosaic project is shown.*

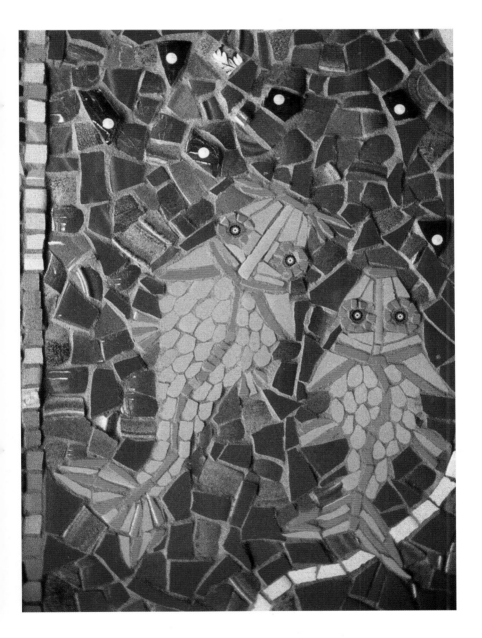

Islamic Inspirations

Islamic mosaics recall the work of the Byzantine era, in their use of lavish materials and intricate designs. Islamic mosaic makers used the medium to spectacular effect, usually as an architecturally related art form and often using preshaped colored tiles to create some of the most incredible mosaics ever seen. The main difference between styles is that in Byzantine art depictions of Christ and saints are an essential subject, while in Islamic art there is no place for the depiction of God, and abstract representations of natural forms, geometric patterns, and inscriptions are applied instead.

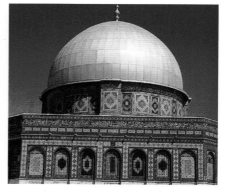

The term "Islamic art" is a very loose one and covers a wide variety of styles, ages, and applications—not only art related to the religion of Islam, but more the arts of all Islamic cultures. The height of Islamic civilization ran through the millennium from the seventh to the seventeenth century, fitting into the period between the collapse of the Roman and Byzantine empires and the rise of the Western European nations. Islamic textiles provide a rich source of inspiration for mosaicists, with the patterns of handwoven rugs made up of small blocks of color, that are in many ways comparable to mosaics. The book also played a central role in Islamic arts, being the most culturally important because of the writing of God's words, and books were beautifully illustrated with fantastic paintings. The significance of writing overflowed into other arts; inscriptions decorated everything from carvings to buildings. Other important arts such as ceramics, glass, metalwork, carved rock crystal, and ivory all show the same symbols.

The Dome of the Rock, set on the site of Jerusalem's Temple Mount where Solomon's temple had once stood, was built in the late seventh century. Often considered the first work of Islamic architecture, this incredible eight-sided building was once entirely covered with mosaics. The exterior mosaics were replaced with tiles in the sixteenth century, but the interior remains almost intact. The lower walls are covered in luxurious marble, cut and fitted into intricate patterns. Around the top of the arcade of the inner facade are beautifully inscripted words, the earliest known

Top Right: *The dazzling roof from The Dome of the Rock*
Above: *Foliage patterns from a Romanian Kilm*
Opposite Page:
Left: *Haroun Mausoleum decorated in intricate mosaics*
Right: *The Dome of the Rock*

evidence for the written text of the Koran. The upper walls of the octagon and the drum are covered in a mosaic of dazzling colors and gilded glass tesserae. Most of the decorations represent flowers, plants, trees, jewels, and chalices; what would once have been used as border or background elements in Byzantine mosaics now became the central subject of the decorations. Another important Islamic building is the Great Mosque of Cordoba, once the capital of Muslim Spain, which was built with workmen and materials from Constantinople and elaborately decorated with gold glass mosaic and carved marble.

Islamic Wall Panel

This intricately patterned panel was designed and made by the students of Stoke Newington Secondary School, in London, where Susan Goldblatt taught as Artist-in-Residence. Working in small groups, the students studied Islamic rugs, tiles, and textiles for inspiration and ideas before working together on their designs.

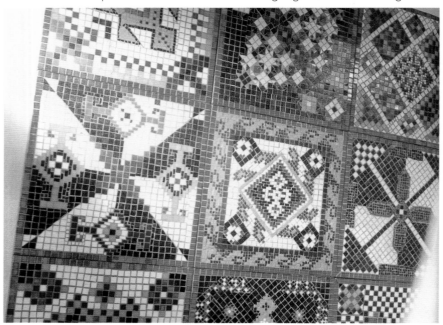

TOOLS AND MATERIALS

- ❑ Graph paper
- ❑ Lead pencils
- ❑ Colored pencils
- ❑ Marking pen
- ❑ Tracing paper
- ❑ Vitreous glass tesserae
- ❑ White or yellow craft glue
- ❑ Particleboard squares
- ❑ Grout

- ❑ Mask and safety glasses
- ❑ Mosaic nippers
- ❑ Paintbrush
- ❑ Scourer
- ❑ Trowel
- ❑ Sponge
- ❑ Bucket
- ❑ Cloths
- ❑ Squeegee

1 Design the sections. Design each of the sections on graph paper, keeping in mind that they will be joined together to make a whole image later on, so consider the balance of geometry and symmetry throughout. Enlarge each section separately using a photocopier and color in the designs with colored pencils. Limit the amount of colors in the design to about five or six and use the same ones for each section; this will create a sense of continuity throughout the panel.

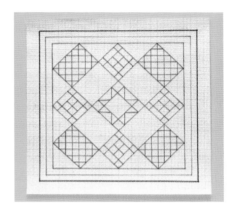

2 Apply glue to particleboard. Prepare the surface of the particleboard by applying a solution of white or yellow craft glue and water (1 part glue: 4 parts water) with a paintbrush. Make sure that all of the particleboard sections are of equal size so that the panel fits together when assembled.

3 Transfer design onto wood. Trace the designs onto the wood. Mark the outlines clearly with a marking pen and write the colors in the appropriate places.

4 Stick down tesserae. Cut the tesserae to the exact sizes required using the mosaic nippers. Be wary of flying shards of glass as you cut and be sure to wear protective glasses and a mask. Stick the tesserae into position by applying a small dab of craft glue to the ridged bottom of the tesserae, the smooth flat side of the tesserae being the top surface. When all the tesserae are in place, allow them to dry overnight before grouting.

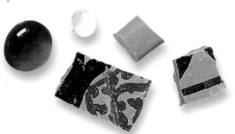

5 Grout the mosaic. In a bucket, mix up a dark grout according to the manufacturer's instructions. Spread the grout over the surface of the mosaic with a trowel, pushing the grout well down into the spaces. Smooth the surface with a squeegee to remove any lumps. Wipe the mosaic with a damp sponge to take off any remaining grout, and polish with a dry cloth when the grout is dry to the touch.

Scrub off any stubborn traces of grout with a scouring pad.

6 Assemble and attach mosaic to wall. When all the sections are completed and the grout has dried thoroughly, assemble the sections together and affix to a large backing board with strong adhesive. Make sure the adhesive has dried thoroughly before attaching it securely to the wall.

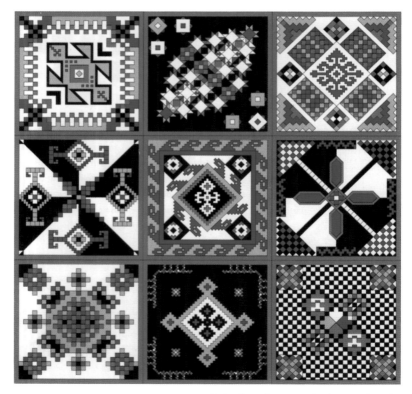

Right: *For reference, a simpler mosaic project, made using similar techniques, is shown.*

Geometric Tabletop

Cool colors, smooth textures, and intricate patterns swirl around this tabletop, inspired by wonderful Islamic geometric patterns and early ceramics, which were often painted cobalt or turquoise blue.

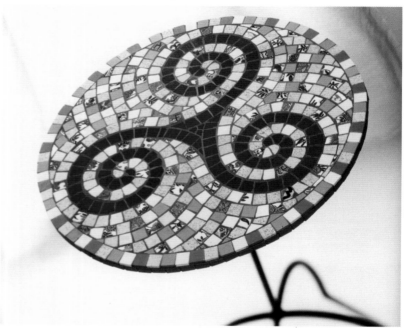

TOOLS AND MATERIALS

❏ Tracing paper
❏ Pencil and marking pen
❏ Plywood (5 ply)
❏ White or yellow craft glue
❏ Ceramic plates with blue willow pattern
❏ Vitreous glass tesserae
❏ Matte ceramic tesserae
❏ Sand
❏ Cement

❏ Table base
❏ Mask and safety glasses
❏ Tile cutters
❏ Mosaic nippers
❏ Craft knife
❏ Squeegee
❏ Rubber gloves
❏ Bucket
❏ Cloths
❏ Screwdriver

1 Prepare the base. Enlarge the design to fit the size of your tabletop with the help of a photocopier. Draw or trace the design onto the wooden board and define the outline clearly with a marking pen. Prepare the surface of the wood.

2 Begin the central swirls. Use mosaic nippers to cut the tesserae to size. When working on curves, nip the edges off the two bottom corners to taper the shape—this helps to make the tesserae flow along the curve. Begin with the central swirls in a strong, dark color first, sticking the tesserae firmly into place with a small dab of craft glue applied to the back of the tile. Outline the swirls with a row of randomly selected pale blues and willow pattern background tesserae. Continue the mosaic around the outside edge, using bolder, darker blue tesserae and some willow pattern tesserae. On the inside edge of this border, follow the curve with a mixture of paler blues and willow pattern in a continuous line, the same colors that are to be used for the background.

3 Complete the background. Following the direction of the pattern shown on the template, build up the background so the tesserae flow in curved lines. The tesserae can be chosen at random, but try to achieve a certain

amount of balance between the various blue shades and the willow pattern. Finish the edge of the tabletop by firmly sticking tesserae all the way around the side of the board. When all the tesserae are affixed, allow the tabletop to dry for a couple of days before grouting.

4 Make the sand and cement mixture. Wearing heavy-duty rubber gloves, slowly add water to a mixture of sand and cement (3 parts sand: 1 part cement) in a bucket until the mixture has a crumbly, moist consistency. Add a little cement dye at this stage if you need to. Spread the sand and cement mixture over the surface of the mosaic with a squeegee, firmly pressing down so that the mixture fills all the spaces, and smooth around the rim of the tabletop so there are no sharp edges. Wipe the mosaic with a wet cloth to remove any excess sand and cement mixture. Repeat with a damp cloth to make sure all the excess has been

smoothed away and finally, polish with a dry cloth.

5 Allow the cement mix to set. The sand and cement mixture will take a couple of days to cure. Allow the tabletop to dry in a cool room with a slightly damp cloth over the mosaic surface. Do not let the cloth dry out.

Place a plastic sheet loosely over the top and check every now and then that the cloth is still damp.

6 Join the top to the base. After a couple of days the tabletop will be ready. Join the table base securely to the bottom and you are ready to go.

Right: *For reference, a similar mosaic project is shown.*

Eastern Inspirations

With a civilization and culture stretching back for thousands of years, the Eastern world offers vast scope for inspiration and ideas. Many objects were made for religious and practical reasons rather than purely aesthetic, with artists and craftsmen following strict guidelines and using traditional skills to create outstanding artwork of symbolic and spiritual significance.

Artists and craftsmen combined intricate detailing, intense color, and the use of religious and spiritual symbolism to create the essential elements of Indian art. This was expressed in many forms—cave shrines, paintings, ornamental carvings, bronze figures of Buddha, sculptures of Hindu gods, and lavishly decorated temples and palaces. Colored glazed tiles used were developed in Lahore, around the beginning of the seventeenth century, and used to adorn buildings with bright, abstract flower and figure designs.

The ancient Chinese did not have much use for myths; later on, mythological creatures such as the dragon, the phoenix, and the unicorn became popular in the retelling of stories and appear over and over again in paintings, textiles, and other art forms. The Chinese excelled in all disciplines of craftsmanship, creating magnificent bronze cast vessels, lacquerwork, and textiles, becoming famous for outstanding porcelain around the middle of the sixteenth century. The first major religion of

ancient Japan was Shinto. Based on nature, sacred beings known as "kami" were worshiped, as well as mountains, streams, rocks, and trees. Shinto shrines and temples were very simple, often single empty rooms raised off the ground on wooden stilts, with no elaborate decoration, as this was frowned upon. Buddhism reached Japan via China in the sixth century A.D., along with elaborate rituals and temples, which were highly decorated and richly ornamental, in contrast to the simple Shinto temples. Under the influence of Zen Buddhists, gardening evolved into an art form. These beautifully designed gardens contained bonsai trees, volcanic rocks, mosses, ponds, streams, and pathways, set out to symbolize aspects of nature and evoke an atmosphere of peace and meditation. Japanese artists and craftsmen were highly skilled in metal casting, sword making, lacquerwork, and miniaturization, as well as creating outstanding paintings on silk and paper. Color and form were the essential elements and much of the painting represented different forms of nature and spirituality.

Although there is no tradition of mosaic making in the East, there are a vast wealth of ideas and subjects, art forms, textile designs, and patterns from which to draw inspiration.

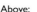

Above:
Feathers and insects' wings were used to decorate fans.
Below: *Eighteenth century Indian book illustration*
Opposite Page
Top: *Nineteenth century vase from Saigon.*
Below: *Japanese origami paper.*

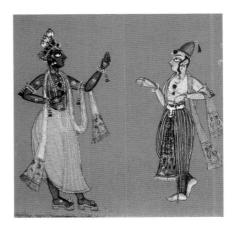

Butterfly Pot Stand

The unusual combination of materials in this mosaic creates a striking contrast between the bold spots and outlines of the body and the delicate wispy lines and iridescent colors of the stained glass wing segments.

TOOLS AND MATERIALS

❑ Construction paper
❑ Pencil
❑ Plywood (5 ply)
❑ White or yellow craft glue
❑ Stained glass
❑ Ceramic tesserae
❑ Vitreous glass tesserae
❑ Sand
❑ Cement

❑ Mask and safety glasses
❑ Scissors
❑ Tile cutters
❑ Mosaic nippers
❑ Craft knife
❑ Squeegee
❑ Rubber gloves
❑ Bucket
❑ Cloths

I When preparing the plywood for this project there is no need to seal the surface with a craft glue solution— the scoring lines help the cement and sand grouting really stick fast to the wood. But, if you do choose to work onto particleboard, the surface will need to be sealed.

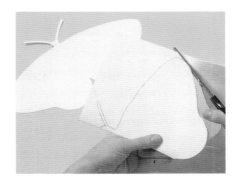

2 Draw or trace the design onto the wooden board and define the outlines clearly with a marking pen. Score the surface of the wood with a sharp craft knife, making deep scratches all over in a crisscross pattern. Break up the tiles and stained glass using the mosaic nippers, being extra careful when cutting the stained glass, as the shards can be extremely sharp.

3 Work on the butterfly detail first, sticking the pieces to the board with a small dot of craft glue. Nibble away at the corners of the square tesserae to make the round dots on the wings. The mosaic will flow better if you use the grain of the stained glass lengthwise through the segments.

4 Any shape or species of butterfly can be used for this design. Take a sheet of construction paper and fold it in half. Draw the outline of one half of a butterfly, the folded line being the point where the outline is divided in half. Cut out the shape with a sharp pair of scissors. The result is a perfectly symmetrical butterfly template to draw around.

5 Fill in the background. First, make an outline of the butterfly with the background color, then follow the curve of the outside edge, so the tesserae flow around the butterfly shape. When the background is complete, apply tesserae to the rim of the board and allow them to dry for a couple of days before grouting.

6 Make sand and cement mixture. In a bucket, slowly add a little water to a mixture of sand and cement (3 parts sand: 1 part cement), until the mixture is moist and crumbly, not wet. At this stage you can add a little cement dye to get the color you require. Apply the sand and cement mixture with a squeegee, pressing down hard so the mixture fills in all the openings, and smooth around the edge of the rim so there are no sharp edges. Wipe the surface with a wet cloth, taking away all the excess sand and cement. Repeat the process with a moist cloth until all the excess has been smoothed away, and then polish with a dry cloth.

7 Allow to dry. Let the project dry in a cool room. Place a slightly damp cloth over the mosaic and leave it alone for a couple of days to allow the cement to cure. Do not allow the cloth to dry out; make sure it stays moist by loosely covering with a plastic sheet.

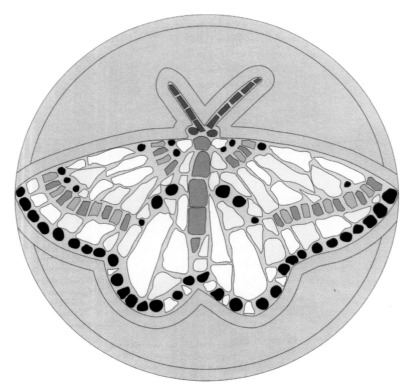

Right: *For reference, a similar mosaic project is shown.*

Wave Backsplash

Cool watery colors and overlapping waves provide a calm and soothing surround for this mirror and backsplash, based on a traditional Japanese repeating pattern. Although this particular project is made on a wooden backing board, it could be applied directly to the area above the sink.

TOOLS AND MATERIALS

❏ Tracing paper
❏ Pencil
❏ Marking pen
❏ Unglazed ceramic tesserae
❏ White or yellow craft glue
❏ Gray grout
❏ Acrylic paint
❏ Particleboard
❏ Mirror
❏ Sandpaper

❏ Jigsaw
❏ Mask and safety glasses
❏ Mosaic nippers
❏ Tile cutters
❏ Small trowel
❏ Paintbrush
❏ Squeegee
❏ Bucket
❏ Sponge
❏ Cloth

1 Modify and trace the design. Measure the width of the sink and area above for the backsplash and mirror. Enlarge and modify the design accordingly and trace the adapted design onto particleboard, clearly defining the outline with a marking pen.

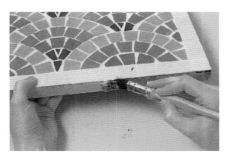

2 Cut and prepare the wood. Using a jigsaw, carefully cut the wood along the outline. Smooth the rough edges away with sandpaper and prepare the surface of the wood with a solution of craft glue and water (1 part glue: 4 parts water). Do this on both sides of the wood to protect it from bathroom condensation and to avoid warping. Allow to dry thoroughly before doing the mosaic.

3 Glue the mirror. Measure the size mirror you require and have this cut by a professional glass cutter. Stick the mirror into position on the wooden board with a generous layer of craft glue. Press down firmly and let dry.

4 Begin sticking down tesserae. Break the ceramic tiles into small squares using the tile cutters, which can be nibbled into shape later on, or use little ceramic mosaic tiles that do not require much in the way of cutting at this stage. Keep the ceramic tesserae in piles of the same color and give each color a number. Mark the numbers of

the colors onto the board according to the design. Starting with the outside edge, begin sticking the tesserae into position with a small dab of craft glue, using each of the colors in turn. You may not want to be that systematic, but try not to get tesserae of the same color side by side around the edge. Once all the squares are in position around the edge, begin working on the inside section of the mosaic.

5 Complete sticking and allow to dry. Using the mosaic nippers, snip away at the corners of the ceramic squares to taper them into shape. Position the tesserae so they create an even flow around the curved shapes of the design. When all the tesserae have been affixed in place, let the project dry overnight before grouting.

6 Make powdered gray grout. In a bucket add water to powdered gray grout until it reaches a smooth buttery consistency. If you have only plain white grout this can be colored by

adding grout dye or pigment to the water before mixing with the powder. Remember that the grout will usually dry much lighter, so it might be worth doing a sample first.

7 Grout the mosaic. Spread the grout over the mosaic with a small trowel, being careful not to scratch the mirror, and pushing the grout well into the spaces between the tesserae. Wipe off excess lumps with a rubber squeegee.

8 Wipe down and polish the mosaic. Take a damp sponge and wipe the surface of the mosaic to remove any remaining grout. When the grout is dry to the touch, polish it with a dry lint-free cloth.

9 Allow to dry and then affix to wall. Allow the mosaic to dry thoroughly, somewhere flat, for a couple of days before fixing it to the wall above the sink.

Cool muted tones of unglazed ceramic tiles are just one option for this classic backsplash mirror. You could choose colors to complement your bathroom and incorporate any existing tiles that you may have spare.

Right: *For reference, a mosaic backsplash of a different type is shown.*

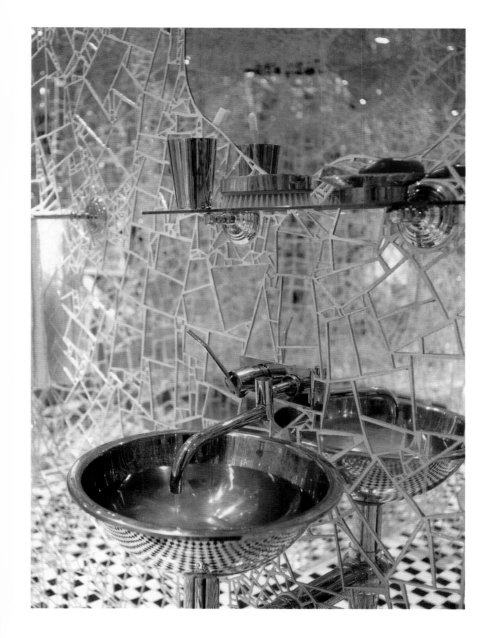

Celestial Ceiling

Inspiration: starry sky. Vaulted ceiling, Mausoleum of Galla Placidia, Ravenna, Italy, fifth century A.D.. The ceiling is part of a total mosaic scheme in the compact interior of the Mausoleum of Galla Placidia. Inside, the ambience is glowing and mesmeric as myriad golden and colored tesserae glimmer in the mellow amber light given by the alabaster windows. The barrel vault at the entrance is depicted as a celestial sky with hosts of spangled stars in white, gold, red, and light and dark blue on an indigo night background. The mosaic covering is textural, dazzlingly beautiful, and wondrous.

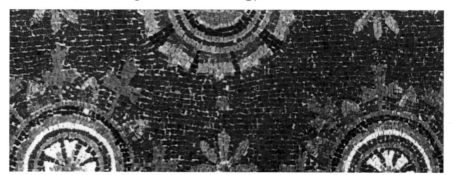

TOOLS AND MATERIALS

- Protective wear
- 1/2 inch (12 mm) marine plywood drill
- Countersink
- Screws
- Wall plugs
- White household glue
- Spatulas
- Palette knives
- Mosaic nippers
- Glass cutters
- Compasses
- Pencils
- Cement adhesive
- Water/cement containers
- Trowels
- Cloths
- Squeegee
- Cement grout
- Black cement pigment
- Masonry brush
- Silver/aluminum leaf
- Glazed white tiles
- Assorted white tesserae
- White patterned china
- Glazed black tiles
- Assorted black tesserae
- Variegated tiles
- Thin/thick mirror and mirror tiles
- Glass globules

The design emulated the starry aspect
of the vault of Galla Placidia in
Ravenna, using a galaxy of large
radiating stars, small six-pointed stars,
large rosettes, and tiny mirror domes.

1 Wood was cut to fit a ceiling 11 × 6
feet (3.56 × 1.83 m). It was divided up
into 11 equal panels for easier and
manageable working. Before
commencing work, the wooden panels
were fixed in place to the ceiling, and
holes drilled and countersunk. The
panels were then taken down and the
underside numbered according to a
continuous plan, 1 to 11, for easy
reassembling.

2 For the mirror domes, make up a
quantity of cement adhesive to form a
thickish paste. Using a pointed palette
knife spread a little directly onto the
marine plywood, forming a small
cement dome.

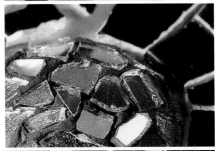

3 Using the nippers with great care to
avoid any splintering, cut the thin
mirror into small tesserae and fix to
the cement mound.

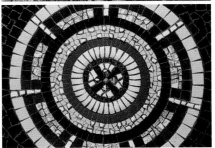

4 Surround the mirrored mound with
black glazed ceramic tesserae in Opus
Palladianum—irregular-shaped pieces.
This material is used solely for the
background to create a uniform color
on which the stars may shine to
greatest advantage.

5 For the rosettes/radiating stars, use an assortment of china, glass tesserae, tile, and mirror. Compass-drawn circles will help mark the layers for fixing the encircling tesserae. Our limitation was one of color—there wasn't any! Just black, white, and silvered mirror. Make the rosettes somewhat smaller than the radiating stars.

6 For the small pointed stars, use simple white tiles for the six-pointed fingers. Keep clear of the countersunk drill holes. Tesserae will be inserted after the ceiling has been fixed in permanent position, to camouflage the fixing points. A glass globule was inserted at the center of each star.

7 Some glass globules are transparent. Rather than allow the wooden base to show through, the glass can be backed with silver leaf. Spread a little white household glue uniformly over the flat back of the glass globule and place on a square of aluminum/silver leaf. Leave for approximately two hours before gently lifting off. The silver leaf has made a perfect metal backing for the glass globule, which can be placed at the center of the small star. When completed, grout—adding black pigment to the grout—and clean and polish with a dry masonry brush before permanent fixing.

Right: *Finished piece. Concept and design Elaine M. Goodwin; executed by EMG with Eve Jennings, Glen Morgan, and Rhanwen Vickers.*

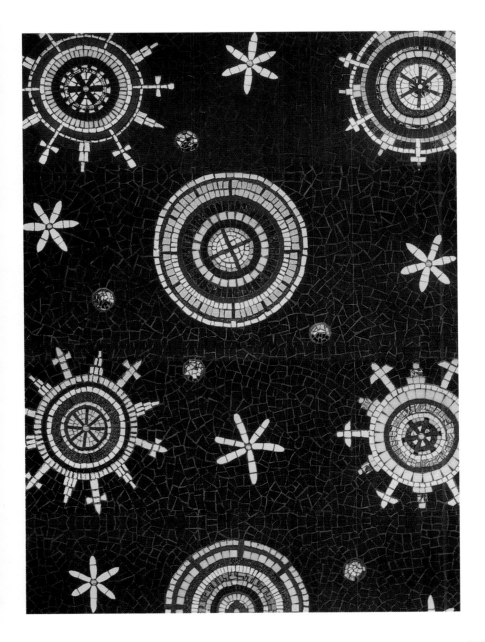

Italian Mirror

The façade of the cathedral at Orvieto, a hill town in Tuscany, to the south of Florence, glistens with marble and mosaic gold. The gold has a truly remarkable brilliance. The spiral marble columns and arched doorways are entwined and decorated with colorful mosaic patterning.

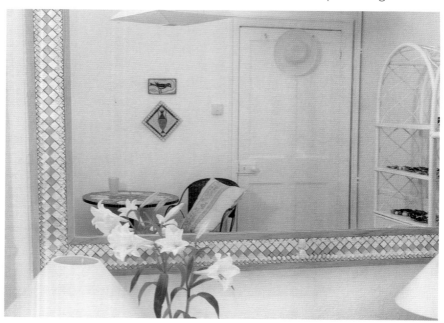

TOOLS AND MATERIALS

❏ Protective wear
❏ Wooden frame
❏ Screws
❏ Drill
❏ Countersink
❏ Wall plugs
❏ Sandpaper
❏ Wood varnish
❏ Brush

❏ Mirror glass, ¹/4 inch (6 mm) thick
❏ White household glue
❏ Spatula
❏ Marble tesserae
❏ Gold smalti (or gold-luster china)
❏ Silver smalti, plain and rippled and revered (or mirror tiles)
❏ Alabaster scarabs (or other objects of art)

1 Design and assemble a mirror frame to the shape required to take the mirror glass. It is important to drill and countersink a sufficient number of holes, approximately one drill hole for every 14 inches (35 cm), before beginning the mosaic. If possible, affix the frame to the wall by drilling and using the wall plugs, but take down again before starting work. Since a mirror and frame can be very heavy, this will greatly assist the final fixing to the wall. Be sure there is a recessed panel to take the mosaic within a raised border of 1/4 inch (6 mm) depth.

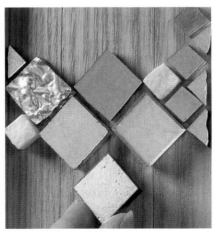

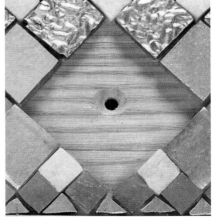

2 Using square and triangular tesserae of differing size, create a design to fit exactly the recessed area.

3 When fixing the tesserae to the wood, keep well clear of the drill holes. After the frame is in place, this area will be covered with the tesserae to create a seamless surface and disguise the fixing points.

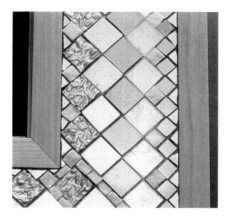

4 Instead of continuing the design into the corners, create small areas of interest by including the scarabs (or objets d'art, jewels, coins, and so on).

5 On one (or more) of the sides, vary the design. In this case, two larger scarabs were used at the center of a line of smaller scarabs at the bottom of the mirror frame.

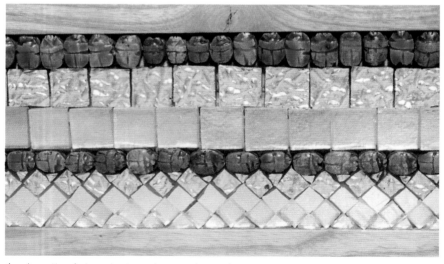

An alternative design using turquoise ceramic scarabs from Egypt to create a richly colorful variant.

Right: *For reference, a similar mosaic project is shown.*

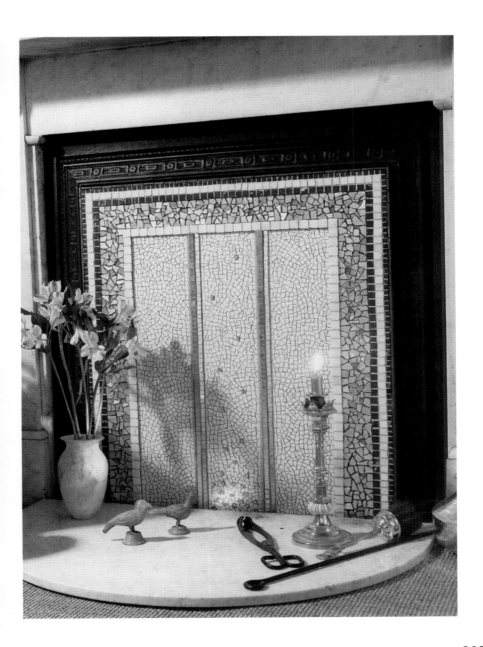

Using Letters

The wondrous extravaganza that is the Albert Memorial in London was designed by George Gilbert Scott, whose use of gilded metalwork, glass jewels, polished stones, and mosaic work was in turn inspired by reliquaries, altar canopies, and shrines seen while he was traveling through continental Europe.

TOOLS AND MATERIALS
- ❏ Protective wear
- ❏ Paper
- ❏ Felt-tip pen
- ❏ Carbon paper
- ❏ Pencil
- ❏ Strong, brown paper water-soluble gum
- ❏ Brush
- ❏ Wooden board (for working on and tamping)
- ❏ Sticky tape
- ❏ Mosaic nippers
- ❏ Rapid cement-adhesive trowel
- ❏ Cement grout
- ❏ Masonry cleaner water/cement
- ❏ Containers hammer
- ❏ Masonry paint (optional)
- ❏ Green vitreous glass
- ❏ Copper-green vitreous glass
- ❏ Green-glazed tiles
- ❏ Black vitreous glass
- ❏ White ceramic mosaic gold/gold-finish china

1 Design the logo for a specific external situation. The lozenge-shaped logo measures 24 × 34 inches (61 × 86 cm). Strengthen the drawing with a felt-tip pen on white paper. Move the drawing to brown paper by turning over and tracing through, using carbon paper to transfer the image. In this manner the lettering is conveniently reversed for working on in the indirect method. Firm up the design using a felt-tip pen. In some cases the design may benefit by being taped down securely to a board for working on.

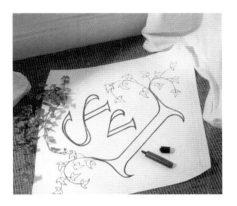

2 Outline the letters with a running line of black glass and fill in using a combination of green glass and green-glazed ceramic. Apply to the brown paper face down, using the water-based gum.

3 In the illuminated letter take special care with the flow of the running line to give a continuous movement. For example, when two lines converge, give dominance to one over the other for the most natural sweep of the line. Frame the design with a single row of white tesserae.

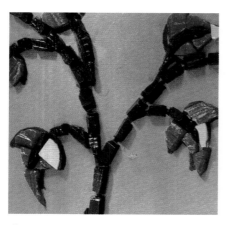
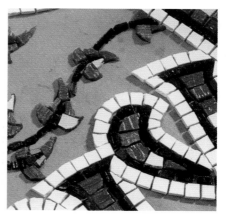

4 Continue to mosaic the stems and trailing ivy forms. In this case the reverse side of the gold was needed and was stuck this side down. Continue to frame the mosaic with one more row of both glass and ceramic tesserae.

5 Outline the letters and image with one line of white background tesserae. Take care around the tiny ivyleaf contours. When completely filled in and dry, trowel a smooth layer of rapid cement adhesive on to the outside wall. Positioning carefully, transfer the mosaic on its paper backing to the wall, and gently tamp flat with the board. As soon as the quick-drying cement has set, dampen the paper until it peels easily away from the mosaic tesserae. This is a moment of revelation! Clean away any excess cement. Grout and clean. Paint the surrounding wall if necessary.

Right: *With a simple color palette of green, white, black, and gold, the sign reads with a delicate elegance and clarity, enhancing the white painted wall with its clinging ivy and playful shadows.*

Wall Sculpture

The genius of the Spanish architect and artist Antonio Gaudi was allowed to flower under the patronage and friendship of that most wealthy Catalan industrialist and nobleman, Don Eusebio Guell Bacigalupi. Inspired by English garden cities, Guell decided to instigate the creation of a garden suburb, and commissioned Gaudi to join with him in realizing this vision. The plan failed, but the world gained an extraordinary and wondrous public garden.

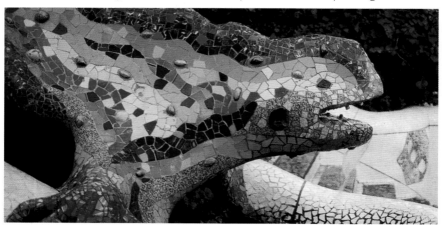

TOOLS AND MATERIALS

❏ Protective wear
❏ Lizard Sculpture (either make it yourself or buy a ready-made garden center sculpture, about 18 inches (46 cm)
❏ 4B or #1 pencil
❏ Cement adhesive
❏ Waterproof white household glue
❏ Trowel
❏ Water / cement containers
❏ Palette knife
❏ Mosaic nippers
❏ Knife

❏ Tweezers / dental probes
❏ Ready-mixed cement grout
❏ Masonry cleaner
❏ Brush
❏ Cloths
❏ Wire (optional)
❏ Scrim / glaze (optional)
❏ Assorted golden- and orange-colored china, tile, lusterware, gold
❏ Assorted green china
❏ Assorted turquoise earthware, glass, reserve silver (blue metal-leaf-backed glass)
❏ Assorted red china, tile

1 Much of the material used for the lizard was recycled or from broken chinaware, plus miscellaneous found materials. Make the lizard sculpture yourself using a wire frame, cement, and scrim/gauze, or buy a similar ready-made sculpture from a garden center.

2 The lizard was coated with a layer of cement adhesive to give a sound, clean, and smooth binding base for the mosaic. Add water to the cement adhesive and brush on.

3 Very simple guidelines were drawn on the back of the lizard with soft pencil marks. Cement adhesive mixed with waterproof white household glue was used to fix the central golden spine on to the tail.

4 Cut small tesserae of china and fix to the back area.

5 Vary the china for the head, and delineate the eye area. The eyes were glass eyes from a market in the Middle East, protective talismans against evil.

6 Use assorted materials to give a rich texture and color.

7 While introducing the turquoise color for the legs, the previously fixed white markings were removed before permanent setting and replaced with reverse silver with its turquoise glass backing for greater color intensity. Feel free to change and "tune" the chosen color palette while work is in progress. When finished, grout, clean, and brush, using the masonry brush.

8 Continue to mosaic the tail area. The fluted border of a plate gave added interest.

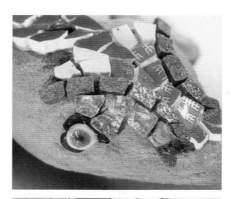

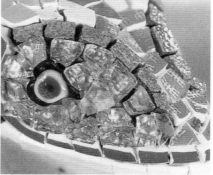

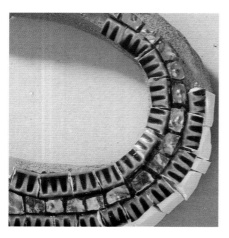

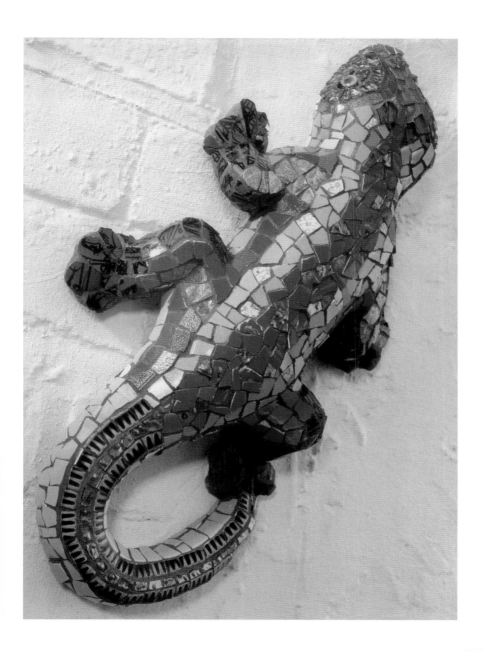

Multicolored Door

It is a big project, but a front door made from mosaic can be the crowning jewel of a beautiful home. It is also a great way of fixing up an old door that's looking a little worn out. This mirrored door gets a good deal of natural sunlight and fills the room with an amazing display of light.

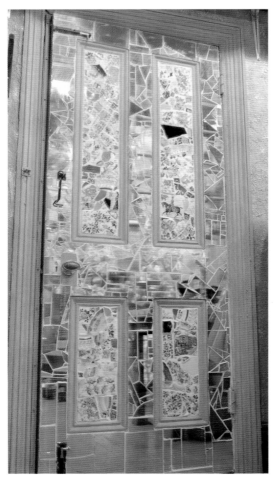

TOOLS AND MATERIALS
- ❏ Mirror glass
- ❏ Ceramic tiles
- ❏ Broken china
- ❏ Tile adhesive
- ❏ White grout
- ❏ Masking tape
- ❏ Gloss paint
- ❏ White or yellow craft glue
- ❏ Glass scorer and cutter
- ❏ Tile cutters
- ❏ Mosaic nippers
- ❏ Mask and safety glasses
- ❏ Trowel
- ❏ Bucket
- ❏ Squeegee
- ❏ Sponge and rags
- ❏ Paintbrush

Prepare the surface of the door by sanding away any old paint or varnish. This can, of course, be done with sandpaper, but when working on large areas it is worth borrowing an electric sander. Cover nearby furniture with drop cloths, open the windows before you start, and always wear a dust mask and protective glasses. Be careful when working around door handles and hinges; any grooves or hard-to-reach places can be finished off with sandpaper.

1 Clean the surface. Prepare the door by sanding down the gloss paint or varnish—you don't need to take it down to the bare wood, just take off the shiny surface. This is best done with an electric sander. Clean away dust and seal with a solution of water and craft glue (1 part glue: 4 parts water). Allow to dry thoroughly.

2 Decorate the panels. Starting on the middle panels first, break up a selection of colored and patterned ceramic tiles, broken china, and white ceramic using the tile cutters and mosaic nippers. Put all the pieces in a pile together so they can be randomly selected. Nibble them into shape and stick them on the door with tile adhesive. Allow to dry while working on the rest of the mosaic.

3 Add the mirror sections. Break up sheets of mirror into manageable sizes before cutting down into smaller tesserae. Be extremely careful while cutting the mirror—wear a safety mask and glasses and work outdoors for this stage if possible. Stick the mirror tesserae on the door with tile adhesive, starting from the outside edge and working toward the center, aligning flat edges of the pieces along the edges of the door, and using smaller tesserae to work around the door handle. Prop the door open so the mosaic cannot be disturbed and let it dry for a couple of days before grouting.

4 Grout the mosaic. Mix up white grout in a bucket and apply it to the mosaic with a trowel. Be gentle with the mirrored sections as the surface scratches fairly easily. Wipe off the excess with a rubber squeegee. Work in sections, starting with the ceramic mosaic panels, and be careful not to spread grout into the wooden grooves. If this does happen, quickly wipe it away with a damp sponge. When the grout is dry to the touch, polish it with a dry cloth.

5 Paint the remaining areas.. Let the grout set completely before painting the wooden inlays and door frame. Cover the mosaic with newspaper, securing the edges with masking tape. Paint the wood with gloss or semigloss, keeping the door securely propped open until the paint is completely dry.

The color scheme for a large project such as this rather depends on the setting, so you might wish to coordinate the colors to suit the room, or alternatively go wild and create something outrageous that will make a truly lasting impression.

Right: *For reference, a mosaic project using a variation of color is shown.*

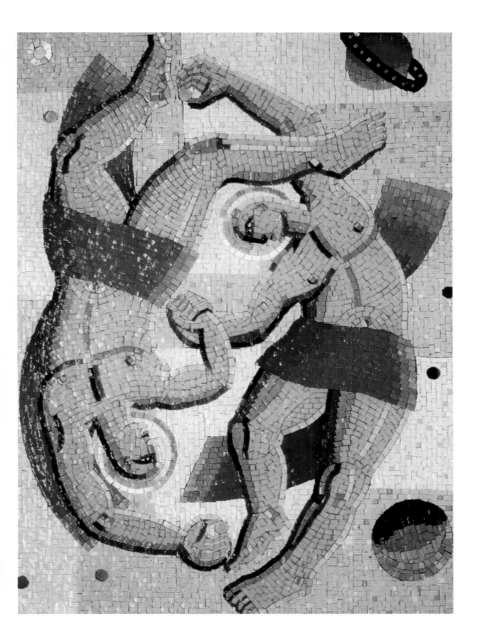

Gallery

This section is intended to inspire you by showing finished mosaics of various subjects made by different styles. Once you start making mosaics, you will quickly develop your own style and be able to apply that style to fresh ideas of your own.

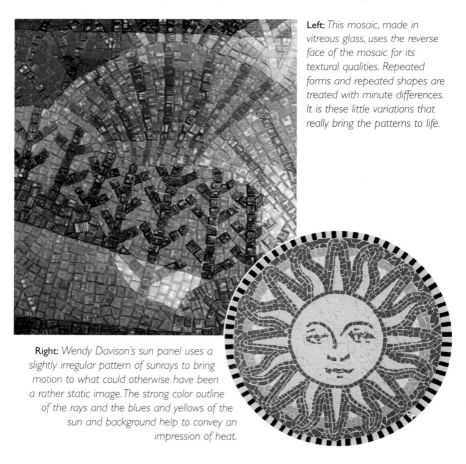

Left: *This mosaic, made in vitreous glass, uses the reverse face of the mosaic for its textural qualities. Repeated forms and repeated shapes are treated with minute differences. It is these little variations that really bring the patterns to life.*

Right: *Wendy Davison's sun panel uses a slightly irregular pattern of sunrays to bring motion to what could otherwise have been a rather static image. The strong color outline of the rays and the blues and yellows of the sun and background help to convey an impression of heat.*

Right: *This mosaic was made using unglazed ceramic. The design is intended to suggest its source of inspiration, which was the color, pattern and themes used on Indian rugs. The grout lines are coursed in order to maximize the amount of cutting needed.*

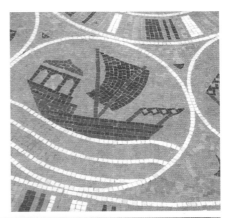

Below: *Here, the coursing of grout lines assists in the description of form. The variety of directions in which the tiles are laid, and the layering effect of using one method of coursing on top of another, helps to give a sense of depth and complexity, further aided by the richness of the colors used.*

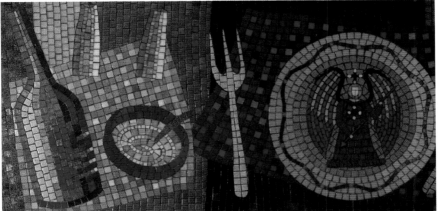

Left: *These mosaics were made for the dining room of a cruise liner. The stars are picked out by gold and silver tesserae, and the lines that describe the imaginary forms of the constellations vary in tone, which helps to give them a shimmering quality.*

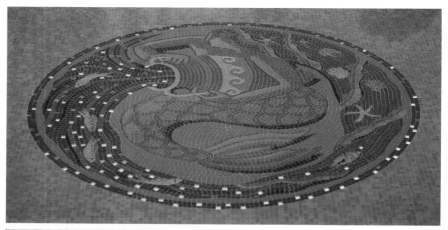

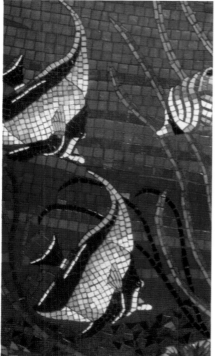

Above: *This mosaic of Aquarius in the form of a mermaid is made in vitreous glass. The bold, graphic design is linked with its watery surroundings by using tiny pieces of mirror scattered throughout the background. These tiles, seen as bright dots in this photograph, change the appearance of the mosaic according to the brightness of the light from day to day.*

Left: *This lively mosaic was made from vitreous glass tiles. The fishes' bodies are described by subtle tonal transitions. Slight differences in the angles at which we view them help to animate the group. Note the different kinds of cuts that are used in this piece.*

Left: *This shower room was made for a client who also used his adjacent library as a guest-room. He liked the idea of having the shower continue the theme, so the whole shower room was lined with mosaic books.*

Right: *These apples hanging from a string were derived from a Spanish still life. The background is cast into deep shadow behind the apples, and the effect is particularly realistic because of the sharp shadows cast by the strings. The apples are given a vivid sense of form by the way that the lines of tiles curve around their shapes.*

GLOSSARY
Terms used in Mosaic Making

andamenti the lines along which mosaic tiles are laid; the lines of coursing of the mosaic.

buttering to butter the back of mosaic tiles is to coat the reverse face with a layer of adhesive or cement slurry.

casting the process of making a solid mosaic object, such as a sand and cement slab within a mold.

casting frame the frame or mold within which a slab is made and set.

cement a mixture of calcinated limestone and clay that, when mixed with sand and water, can be used as a base or backing for a mosaic piece.

cement slurry cement mixed with water to form a creamy mixture that can be used to grout mosaic tiles.

coursing the coursing of tiles is like the coursing of bricks in a building. It is a term that describes the lines along which the tiles are laid, and can refer to the way they line through with one another.

curing leaving cement to set. Curing time is the time it takes for a cement mixture to set solid. Curing is also sometimes referred to as "going off."

direct method the method by which mosaic is laid directly in its permanent location, straight onto its final surface.

emblema a highly sophisticated, finely made mosaic panel used as the center piece of a floor. Roman emblems were often made so that they could be moved from one location to another.

feathering building up the depth of adhesive or sand and cement gradually to bridge a transition between levels on an uneven surface.

fixing setting a mosaic in its final location. The fixing process is the process of setting it in place if it has been laid out in the indirect method. If working in the direct method the laying and fixing process are done at the same time.

grout the cement matrix that fills the gaps between tiles. Grouting refers to the process of applying grout to a mosaic.

honed marble marble that has been polished to a matte rather than a glassy finish.

indirect method a technique whereby mosaic is stuck in reverse onto a temporary surface before being turned over and fixed into place.

laying putting the individual tiles of a mosaic in place.

micromosaic mosaic made from very tiny cut tiles. These can also be used within an ordinary mosaic but to qualify for the term micromosaic the whole piece must be executed with minute tesserae.

nippers a hinged cutting tool for mosaic.

opus the Latin word for work.

pregrouting grouting a mosaic made by the indirect method from the reverse face before it is fixed in place.

render to use sand and cement on a wall as a substrate onto which to fix mosaic.

riven marble marble that has been cut in order to reveal its crystalline inner face.

screed a sand and cement sub-

base on a floor onto which mosaic can be fixed.

setting this term is used both to describe the process of curing cement, and also to describe placing something in position.

smalti enameled glass of the kind used in Byzantine mosaics.

tesserae the components of a mosaic, which may include cut and uncut tiles, pebbles, and found objects.

unglazed ceramic ceramic tiles that have not been glazed with color. They are the same color throughout, rather than having just a surface color as with common household tiles.

vitreous glass square mosaic tiles made in molds from glass paste. They have a smooth top surface and a rough back.

INDEX

INDEX